Royal
Botanic Garden
Edinburgh

How the Garden Grew

A Photographic History of Horticulture at RBGE

Leonie Paterson

ISBN: 978-1-906129-92-7

© Royal Botanic Garden Edinburgh, 2013.

Published by
Royal Botanic Garden Edinburgh, 20A Inverleith Row, Edinburgh, EH3 5LR
www.rbge.org.uk

Proceeds from sales of this book will be used to support the work of RBGE.
The Royal Botanic Garden Edinburgh is a charity registered in Scotland (number SC007983)
and is supported by the Scottish Government's Rural and Environment Science
and Analytical Services Division (RESAS).

Front cover image:
Gardener in a potting shed, from S.F. Hayes collection held at RBGE.

Frontispiece:
Illustrations from *Catalogue of Vegetable and Flower Seeds and Amateur's Guide*.
Dicksons & Co., seed merchants, 1 Waterloo Place, Edinburgh.
John Baxter & Son, Printer, Edinburgh. Undated.

Printed by Meigle Colour Printers Limited, Galashiels
using vegetable-based inks and eco-friendly varnish,
under the control of an environmental Management System.

Contents

Foreword

The Royal Botanic Garden Edinburgh (RBGE) has had a remarkable history in its last 343 years, with several changes of location within Edinburgh. This book provides an excellent opportunity to view many of the changes that have taken place on the current site at Inverleith since we moved here.

These pictures provide a fascinating insight into many of the major developments within the Garden: the machinery and numbers of staff involved in transplanting large trees in years gone by; the developing stages of the Rock Garden; and the different phases of glasshouse construction over the years, from the building of the Temperate Palm House to the relatively recent Exhibition Planthouses.

However no garden would be complete or possible without the skill and dedication of the horticultural staff cultivating and maintaining the plants. The images of Garden staff and students in this book depict not only the fashions of the day, but also the changing tools and techniques used in the daily work of the Garden. This book reminds us that we owe a debt of gratitude to past generations of staff at the Royal Botanic Garden Edinburgh for their vision and hard work. I hope you enjoy this book as much as I have.

David Knott
Curator of Living Collections
Royal Botanic Garden Edinburgh

Introduction

The Royal Botanic Garden Edinburgh (RBGE) has its origins in a small 'physic' garden the size of a tennis court, established by two doctors, Robert Sibbald and Andrew Balfour, in the grounds of Holyrood Palace in 1670, almost 350 years ago. From that time the Garden has moved to different locations in Edinburgh, expanding in size and scope along the way, via a site now buried by Waverley Station and a location on Leith Walk, where vestiges of the Garden once there can still be located. By 1820 it had been decided to move the Garden again, presumably for the last time, to what was then the outskirts of Edinburgh: its current site in Inverleith. The location chosen was a fraction of the size the Garden occupies today, extending roughly only as far west as the Temperate Palm House and Alpine Houses, and as far south as the Pond, but there was room for expansion. In the 1860s we acquired the land of the Royal Caledonian Horticultural Society to the south of the Pond which became our Rock Garden, and in the 1870s we obtained the remaining land of the Inverleith House estate which became our Arboretum.

All through our history the names of our great Regius Keepers (or Directors) and our Heads of Horticulture are heralded; they, after all, have made the decisions which have shaped our organisation into the leading visitor attraction and scientific establishment that it is. But what of the people who did the day-to-day work that makes the Garden a place visitors enjoy spending time? And it is a full-time job; plants don't take days off!

This book aims to redress the balance a little bit whilst showcasing a sample of the photographs held in RBGE's historic Archives. The main objective of our Archive is to collect and preserve letters, papers, photographs and other items relating to individuals or organisations which have been connected in some way with RBGE, botany or horticulture. We are fortunate that this has resulted in some incredible photographs being donated to us, and sometimes even the cameras themselves. Of course we did have our own photographer, Robert Moyes Adam, who had the post of official photographer, or 'Assistant in the Studio' created for him in 1915. He started at RBGE as an Assistant Head Gardener in 1903 and retired in 1949, when he was replaced by Ross Eudall. Prior to that, however, the majority of our photographic record seems to have been produced by members of the Horticulture staff, usually Foremen such as David Sydney Fish and Adam Dewar Richardson (who eventually became Curator or Head Gardener in 1896), who were in possession of cameras and keen to record many of the activities carried out at RBGE and the staff members involved.

We have searched through negatives captured on glass plates and prints produced in our darkrooms or donated to us by ex-staff and students. This resulting selection shows past Garden staff at work with the plants, glimpses of how beds were formed outdoors and how plants were displayed in glasshouses now long gone. Unfortunately, none of the collections searched contained photographs of any of our early female gardeners – we began to employ them in 1897. Names were matched to records held in the Archives whenever possible: a challenge, as so few photographs have names on them, and the records are patchy. It is hoped that by publishing images of some of the unnamed gardeners, it may be that they can be given their names back, which would be a wonderful result. But essentially this is a chance to view some of our archive material, see aspects of the Garden that have now changed (and much that has remained the same), and hopefully to give an impression of how long we have been here and what we do. I hope you enjoy it.

Leonie Paterson, Archivist, Royal Botanic Garden Edinburgh

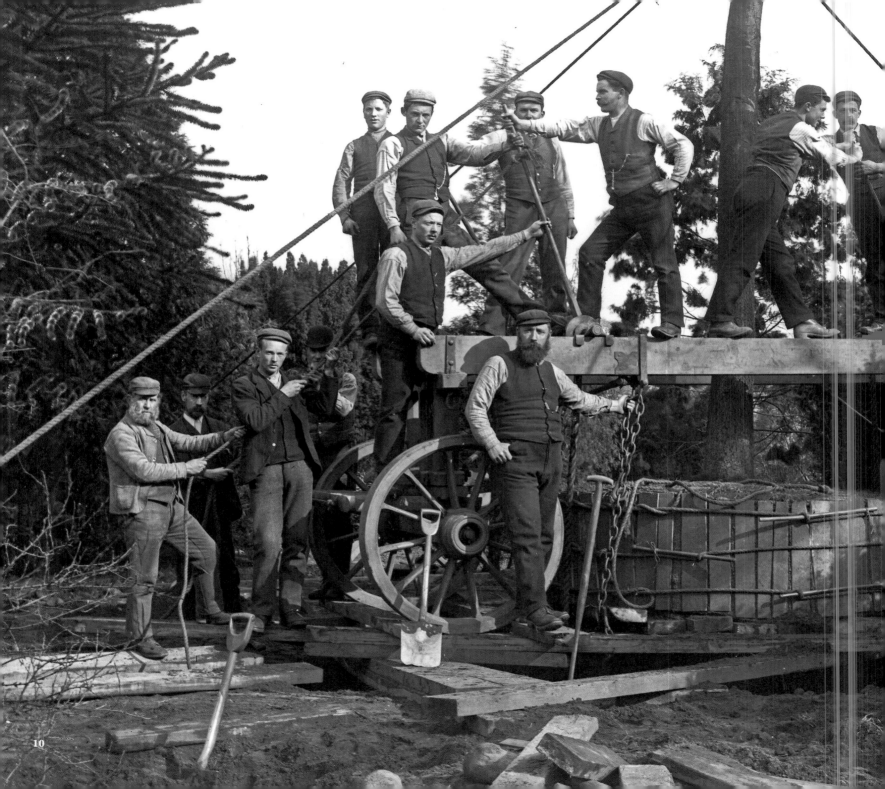

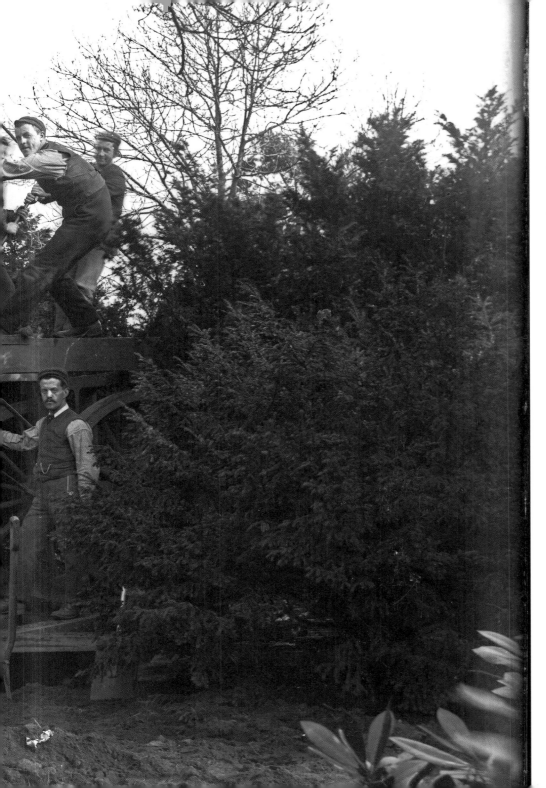

The Great Outdoors

Welcome to the Royal Botanic Garden Edinburgh. The ways in which visitors have entered the Garden at Inverleith in Edinburgh since we have inhabited this site have varied. But throughout, the first thing they experienced was the Garden itself. Some of the areas and vistas would still be familiar today to a visitor from a century ago, others have changed beyond recognition. In this section of the book we have aimed to show how some of our more 'iconic' locations such as the Rock Garden, Pond and the area around the Herbaceous Border used to look, along with some of the horticulture staff who worked on them.

¼ DD 04, 14 March 1894, A.D. Richardson

The Rock Garden has long been an iconic part of the Edinburgh Garden. But the Victorian Rock Garden – with its numerous brick compartments, unnatural structure and columns (some reused from dismantled Edinburgh buildings, some obtained from the Giant's Causeway and Staffa) and *Araucaria* planted on top of small hills, each named after an alpine botanist – was perhaps memorable for all the wrong reasons. Reginald Farrer, the notable plantsman, described "the chaotic hideousness of the result [as] something to be remembered with shudders ever after". It was designed by James McNab and built in the 1860s before being redesigned in a complete overhaul in 1908.

LB396

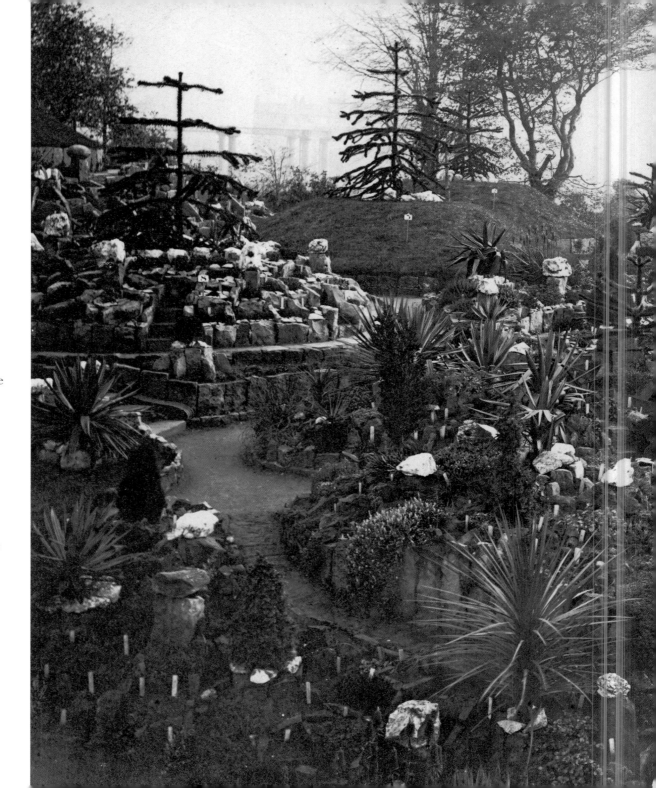

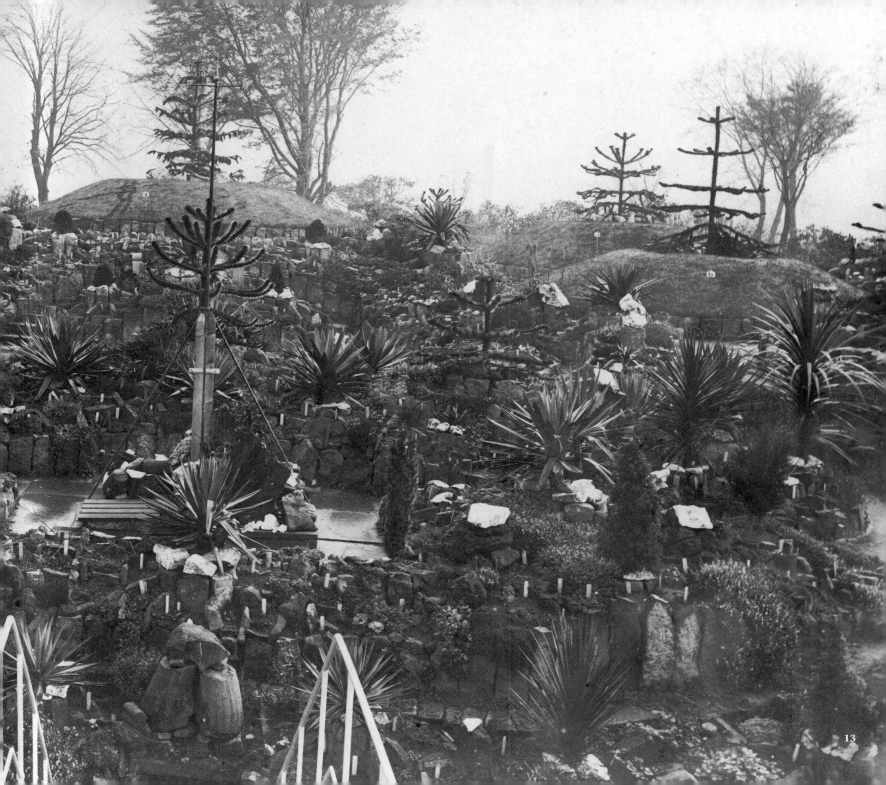

13

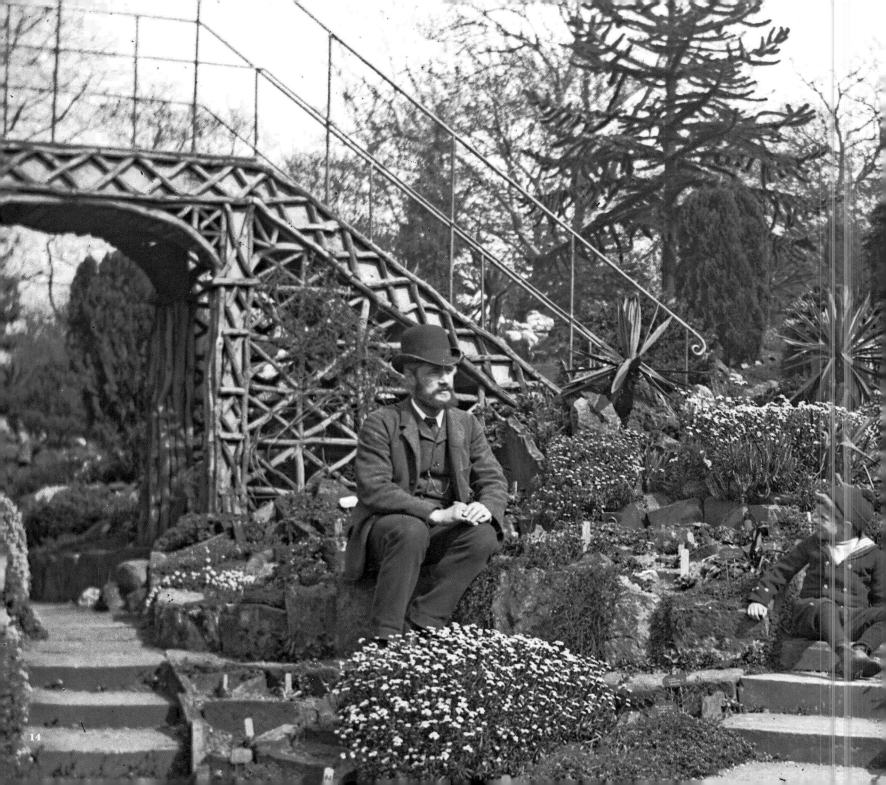

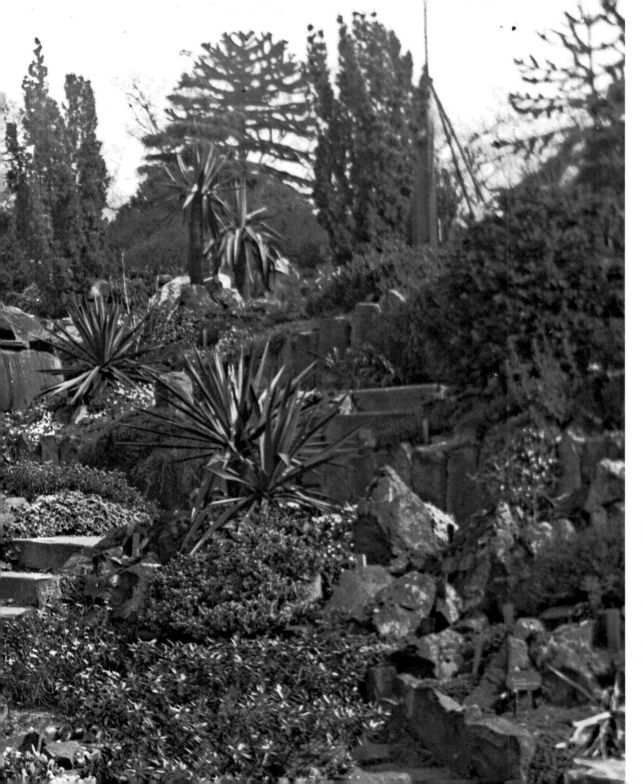

A man and boy enjoying the view in the Victorian Rock Garden in around 1894. The structure in the background was the last piece to remain from a large glasshouse or 'winter garden' situated roughly where the waterfall is today, creating a viewpoint. The winter garden itself was demolished in the early 1890s.

¼ DF 39, c.1894, A.D. Richardson

15

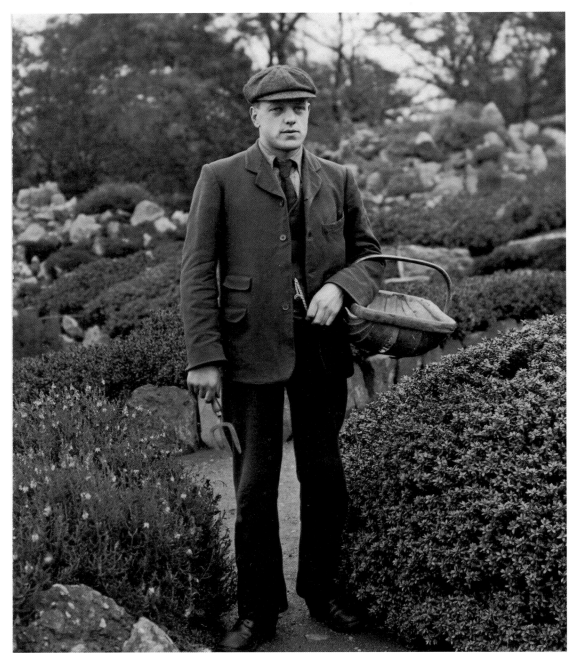

◀ An unnamed gardener hand weeding with a fork and trug in the Edwardian era – the uniform may have changed, but the bulk of the work remains the same today.

No.969, c.1904–1906, attrib. to D.S. Fish

▶ A gardener in the Rock Garden at the turn of the 20th century with notebook and wooden trug.

1/1 D 50, c.1900

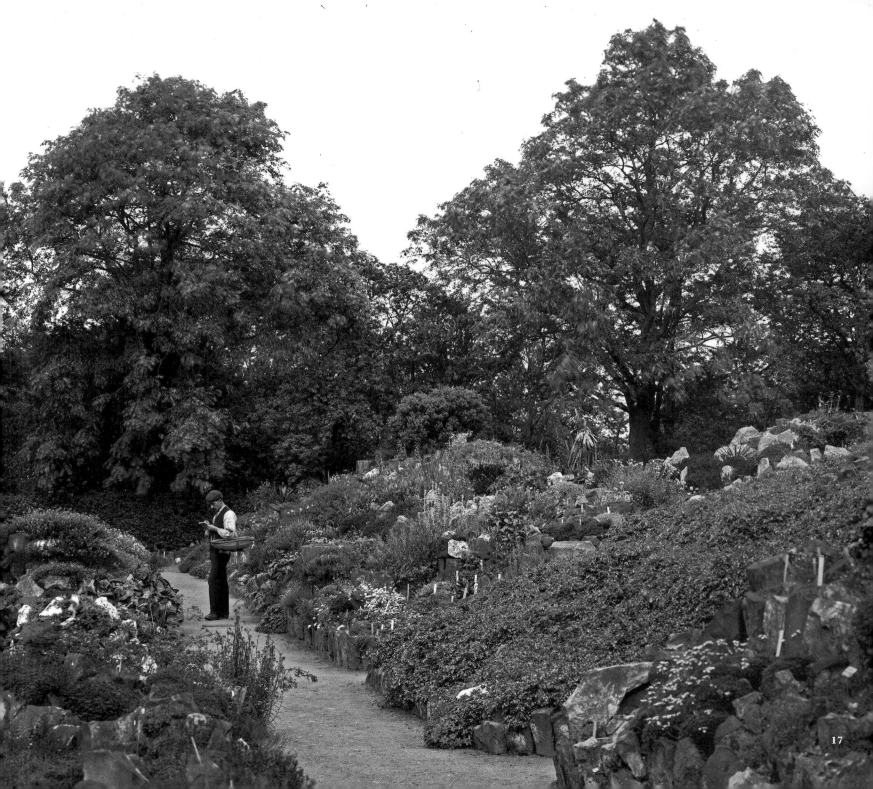

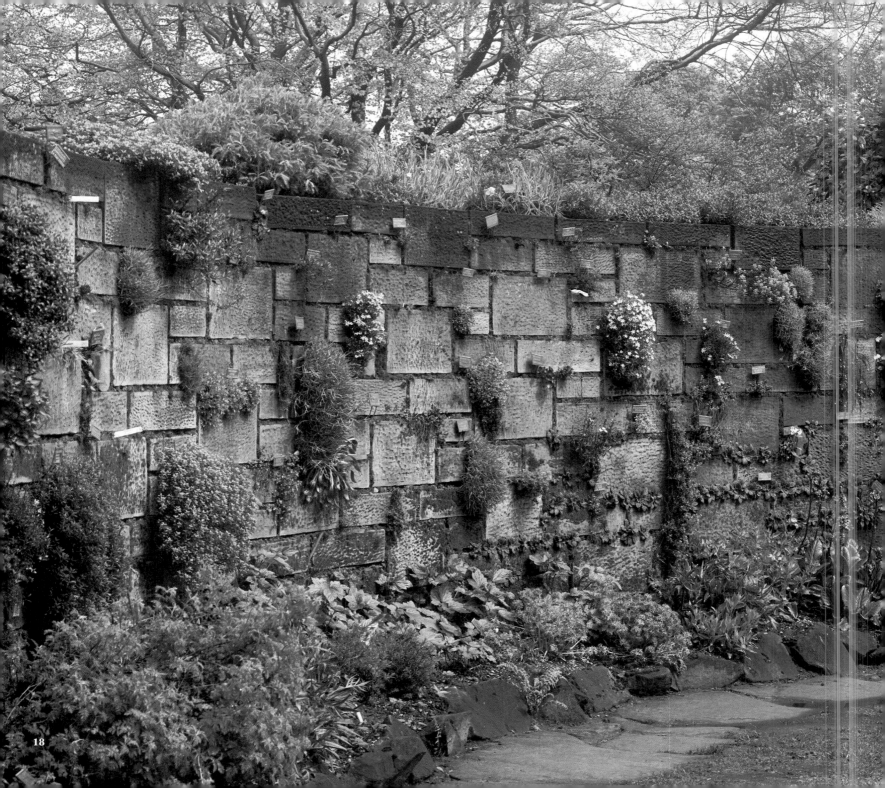

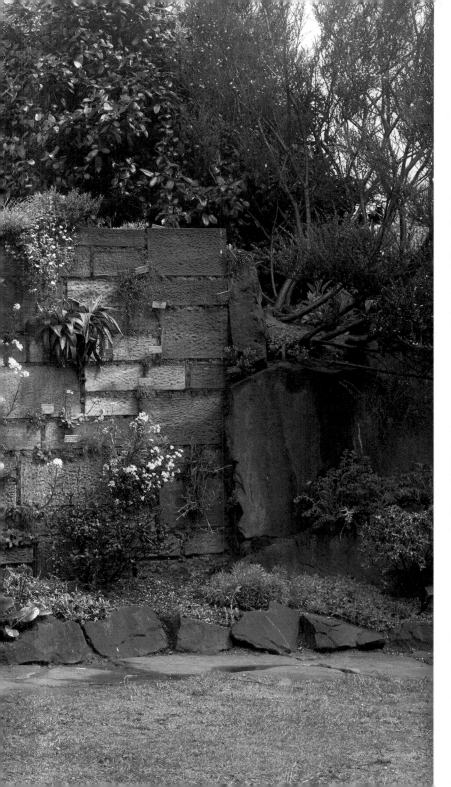

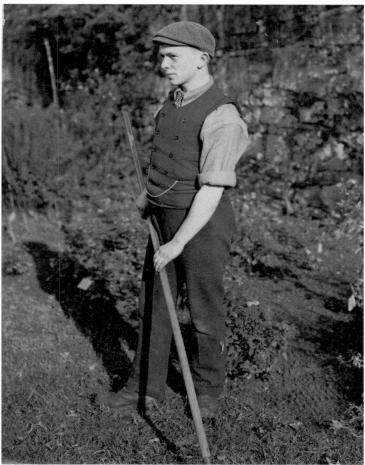

◀ A wall garden constructed of red sandstone once sunk into the south-east corner of the Rock Garden. It was taken down during the complete renovation of the south side of the Rock Garden in 1938. A version of what we would call a crevice garden today it was suitable for plants such as *Ramonda pyrenaica*, some *Saxifraga*, *Lewisia* and *Primula* that prefer to grow on a free-draining vertical face where they can feed off the minerals in the wall. ½ BP 25, 18 May 1926, R.M. Adam

▲ A gardener raking the beds in front of a similar wall to the one in the Rock Garden, possibly at the same location. No.940, c.1900–1906, attrib. to D.S. Fish

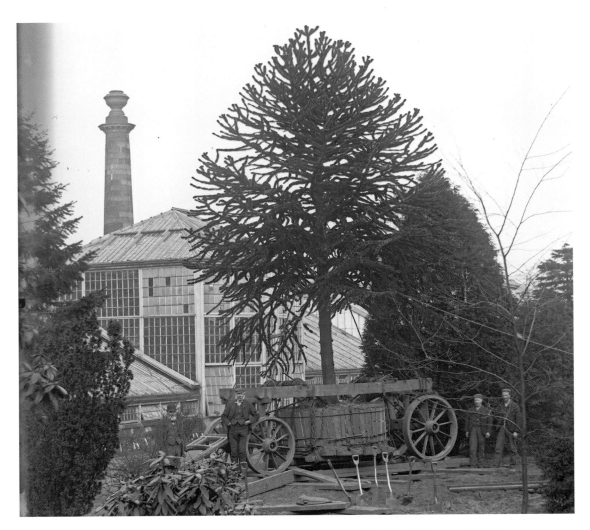

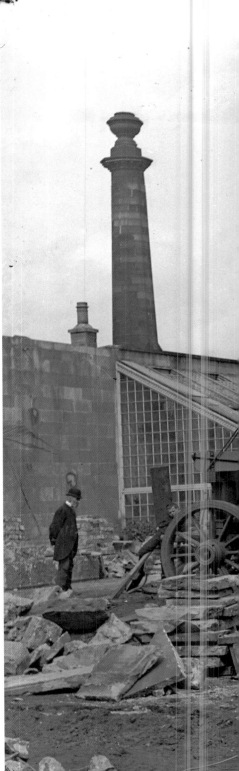

▲ An *Araucaria*, or monkey puzzle tree, has probably just been lifted in this image. The large square houses of the old Glasshouse Range are about to be demolished and new houses covering a wider area erected in their place – many trees would have had to go to make room for them. ¼ DD 01, 1894, A.D. Richardson

▶ A cypress tree (*Chamaecyparis* sp.) is moved out of the way of the new house about to be built in place of the old square one, which has just been demolished. A woman and two children are looking on. Then Regius Keeper Isaac Bayley Balfour's children Agnes (Senga) and Isaac (Bay) would have been similar in age to these children in 1894 and one wonders if this is his family enjoying a privileged view of the tree transporter. ¼ DD 11, 17 July 1894, A.D. Richardson

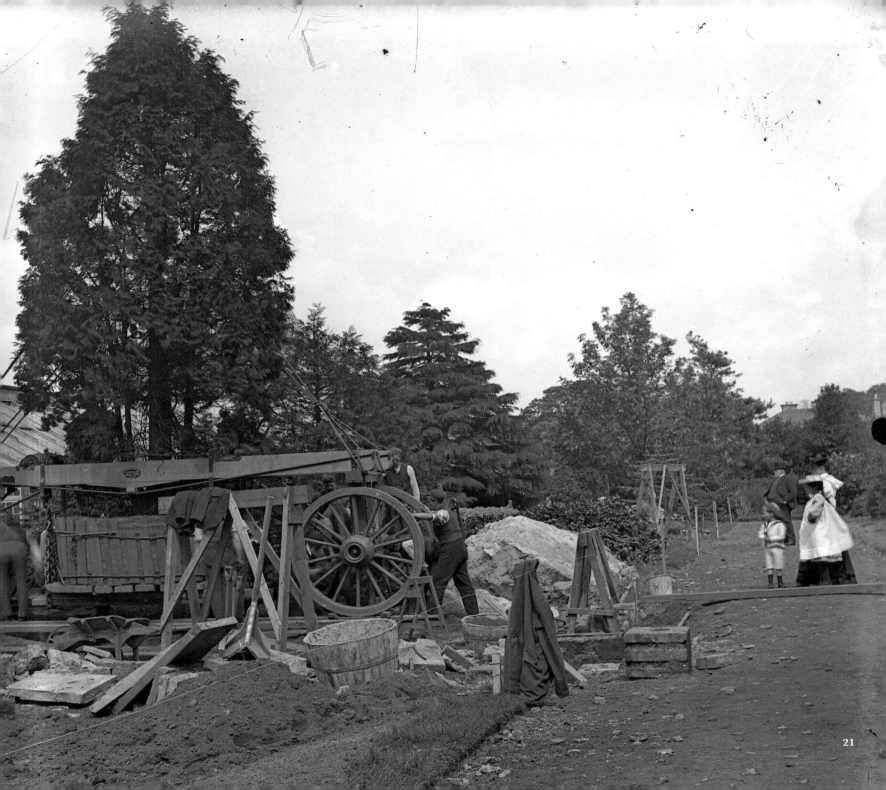

21

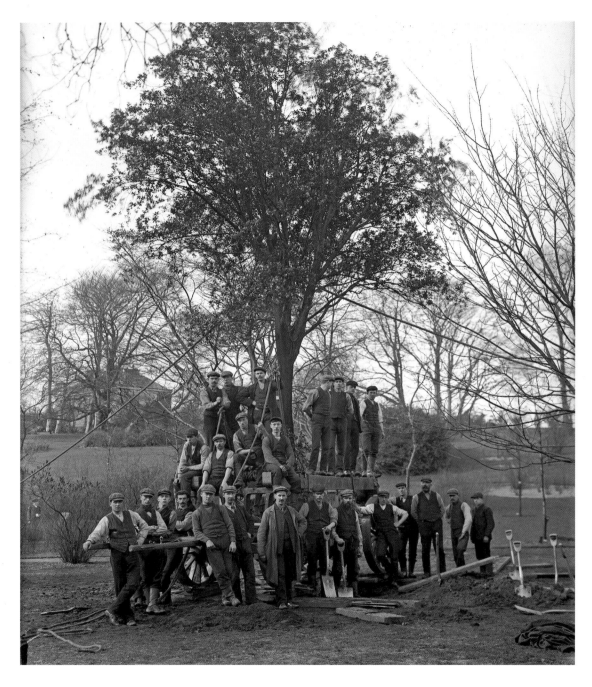

◀ An oak tree, possibly *Quercus libani*, Lebanon oak, after being lifted onto RBGE's tree transporter at a time when it seems a lot of trees were being moved to new locations in the Arboretum. RBGE acquired the ground around Inverleith House (which can be seen in the background) for use as an Arboretum in 1876. Around 20 years on, efforts were being made to group the trees together by type. Look carefully and a lady can be seen on the far left watching the operation from behind some plants.

1/1 R 32, c.1900-1905

▶ A yew tree after being lifted on its way past the Pond to its new location which is likely to have been the area to the north of the East Gate entrance, where there are still yews today. This would have been a familiar sight in Edinburgh around 80 years earlier when RBGE moved its site from Leith Walk to Inverleith and actually transported trees from one location to the other through the streets on a similar contraption!

½ CN 44, c.1900–1906, D.S. Fish

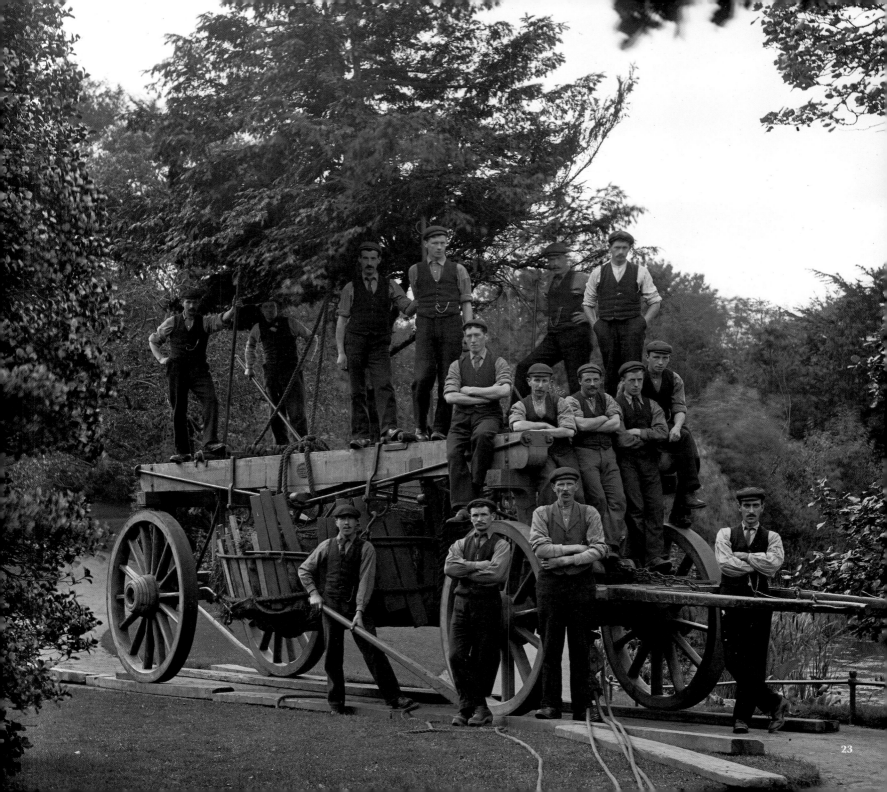

23

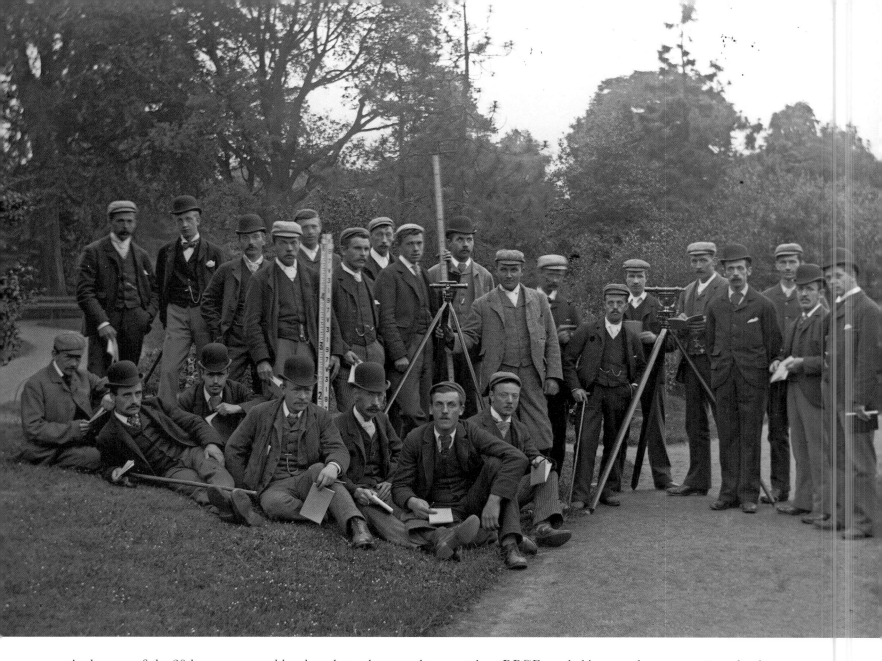

At the turn of the 20th century, roughly when these photographs were taken, RBGE needed increased manpower to redevelop parts of the recently expanded Garden. A system of probationer or apprentice gardeners and foresters was introduced. This usually involved men, although there were some female gardeners from 1897, working for around three years for long hours, few holidays and a weekly wage of 21 shillings …

¼ DF 43, c.1895, A.D. Richardson

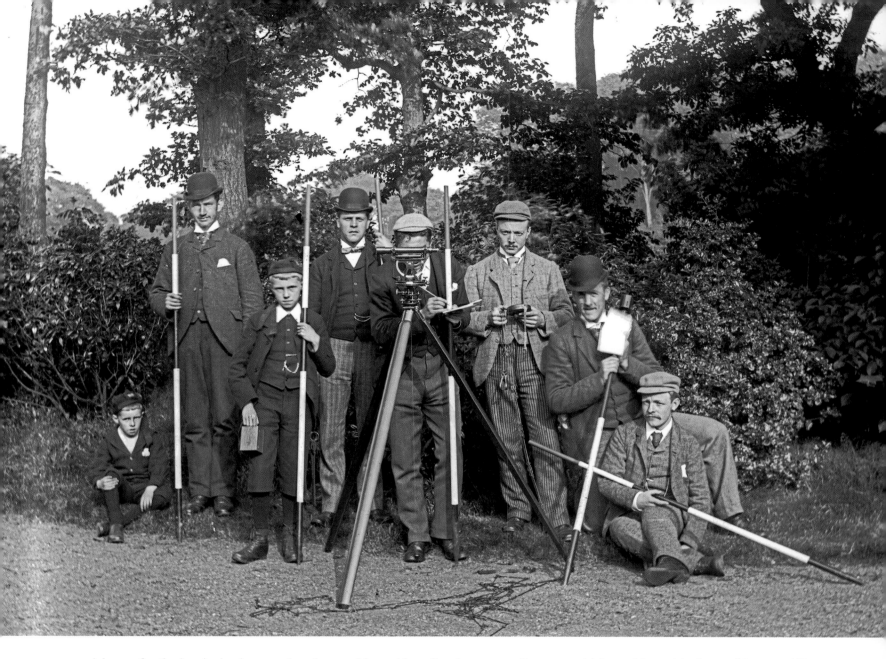

… A bonus for the horticulturists was that they could enrol in a dizzying range of courses which would provide them with extra skills and knowledge to enhance their future job prospects. These included botany, forestry, horticulture, chemistry, physics, book-keeping, geology, meteorology and surveying. These photographs show some of the surveying classes out in the Garden with their instruments and measuring sticks in around 1895.

¼ DF 42, c.1895, A.D. Richardson

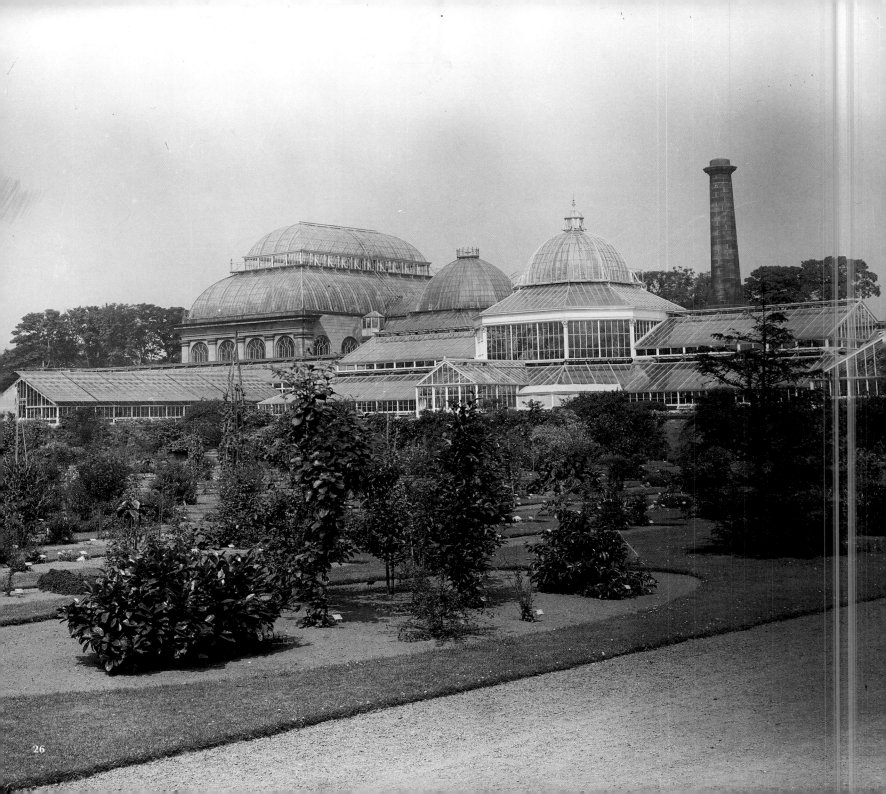

◀ Whereas nowadays one function of a botanic garden can be perceived to be pleasure and relaxation, there was a time when their purpose was very much educational. 'Order Beds', as depicted here, were essential to this. Within each bed plants were arranged by their relationships to one another, so that they could be compared with examples in their own family. In the past, visual characteristics would normally have been used to decide this, whereas now we are more likely to use the plant's DNA.

1/1 M 07, c.1905

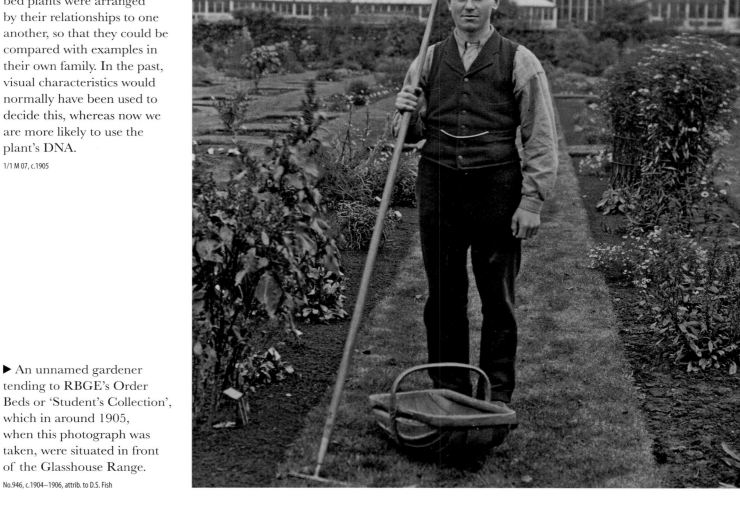

▶ An unnamed gardener tending to RBGE's Order Beds or 'Student's Collection', which in around 1905, when this photograph was taken, were situated in front of the Glasshouse Range.

No.946, c.1904–1906, attrib. to D.S. Fish

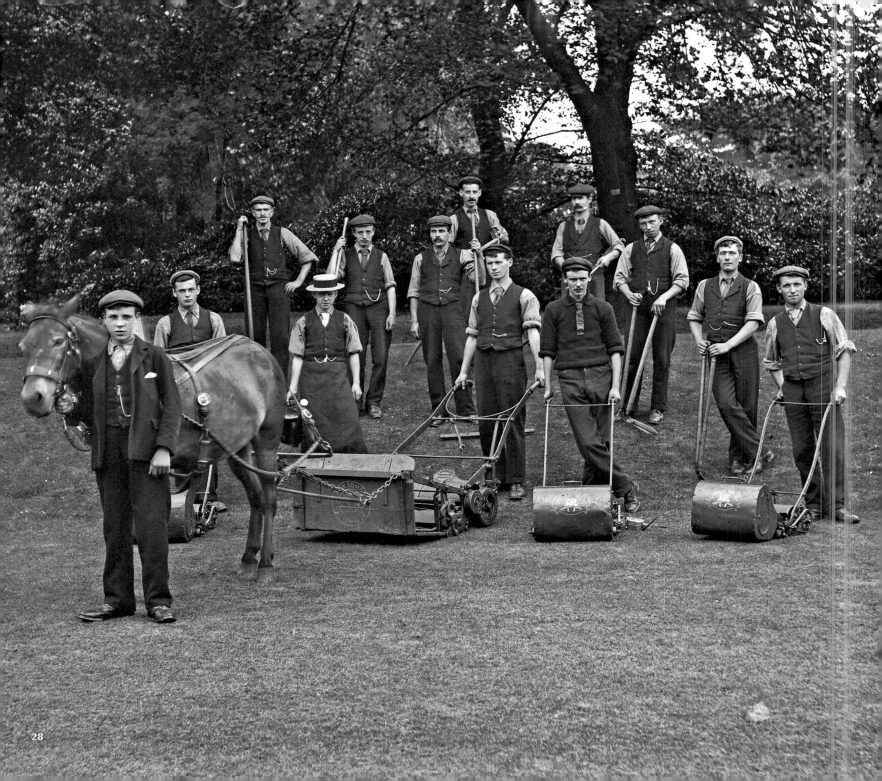

◄ A photograph of the team of gardeners in charge of looking after the RBGE lawns, taken at the West Gate entrance, where the stables were located. The image shows the range of equipment used, such as edging shears, watering cans, rakes and, of course, the pony-drawn lawn mower. Nowadays, much of this work is fully automated, including the use of petrol strimmers and motorised scarifiers.

½ CN 19, c.1904–1906, D.S. Fish

► Until relatively recently the Garden was patrolled by constables, their job being to protect the plants and enforce a long list of rules which at the time of this photograph included prohibiting livestock, artist's equipment and swearing! The Living Collection at RBGE contains plants of practically every kind from all over the world, a similar sort of collection to a zoo or museum, and hence very much worthy of police protection. This constable's uniform bears the monogram of King Edward VII, correlating with the photograph's date of around 1905.

No.933, c.1905, attrib. to D.S. Fish

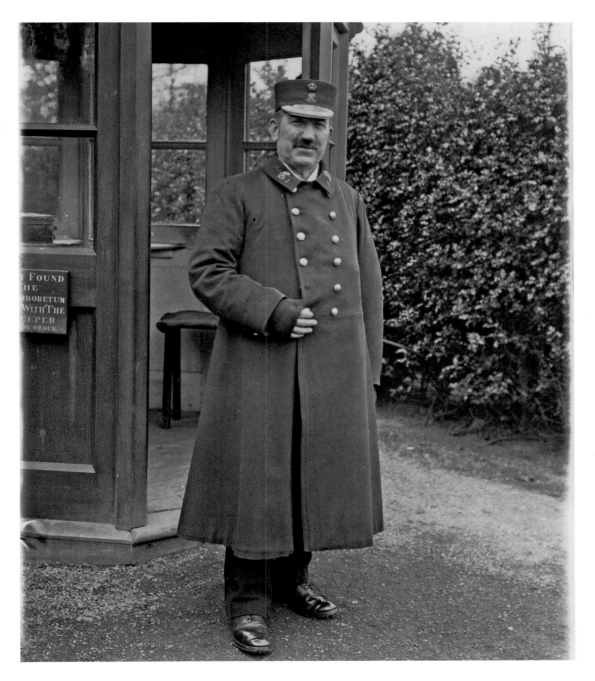

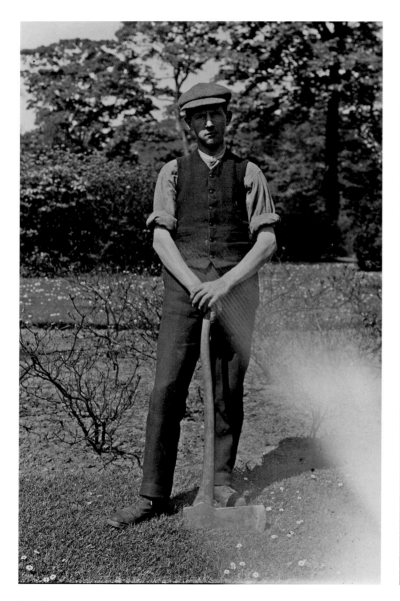

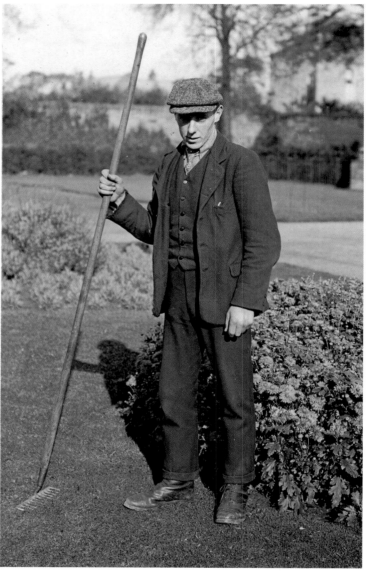

RBGE's probationer or student gardeners could choose from two paths – horticulture or forestry. This unnamed gentleman was presumably learning forestry, armed with a hefty axe – perhaps for a little light pruning!

No.966 c.1904–1906, attrib. to D.S. Fish

William Ritchie, raking the lawns outside the Temperate Palm House. He started at RBGE in 1905, and left two years later to become a rubber collector in Liberia, West Africa.

No.948, 1905–1907, attrib. to D.S. Fish

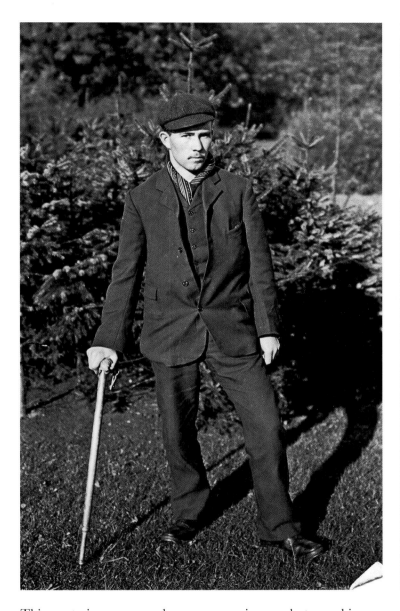

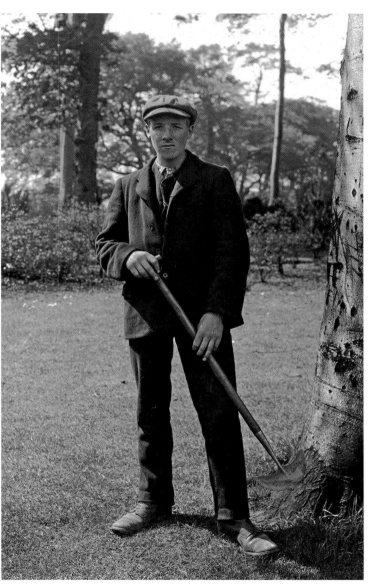

This mysterious unnamed man appears in our photographic archive holding a stick which doesn't seem to have a horticultural purpose. Could it be that he was brought in to deal with a problematic infestation of moles?

No.970, c.1904–1906, attrib. to D.S. Fish

An unnamed gardener holding a half-moon turf cutter, likely used to edge the lawns. Much of this kind of work is still done by hand today.

No.965, c.1904–1906, attrib. to D.S. Fish

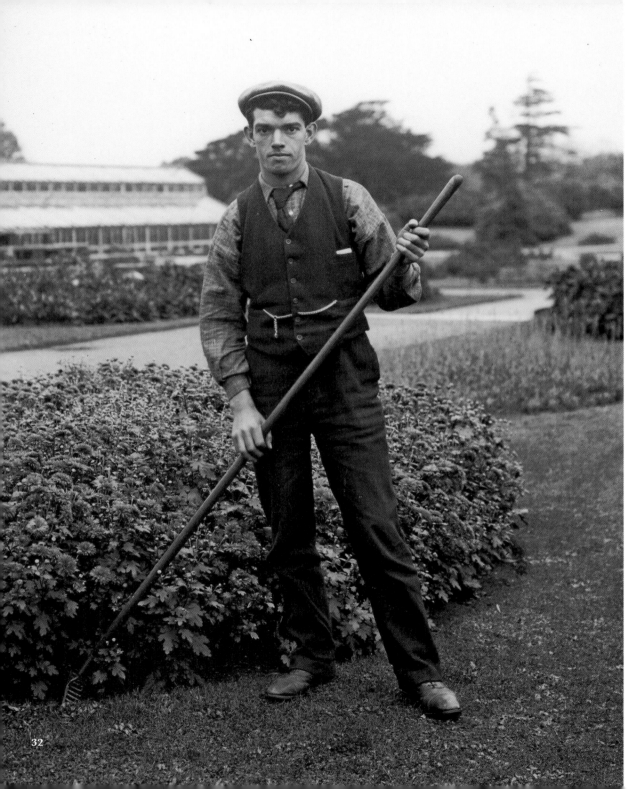

A gardener raking the lawns to the west of the Glasshouse Range.

No.947, c.1905–1907, attrib. to D.S. Fish

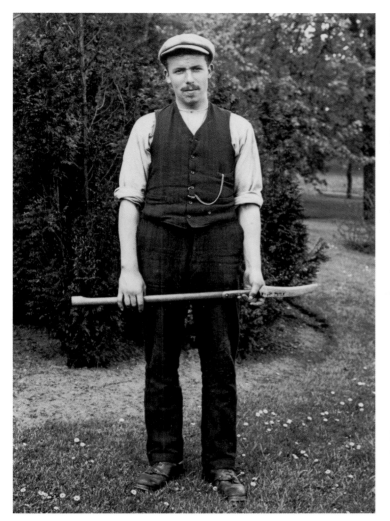

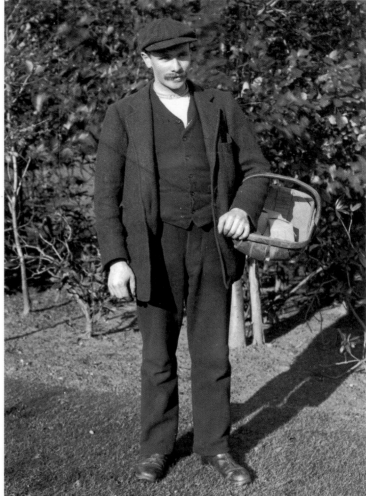

William Fernie was a probationer forester at RBGE between 1908 and 1909. He was the son of the Head Forester of the Balcarres Estate in Fife, from where his reference states: "a good workman and uses a scythe especially well". Here he holds a tool known as a 'slasher', used for taming unruly undergrowth or, in a forester's case, removing suckers from the base of trees. Fernie left before his probation period was over to take charge of the Balcarres Forestry Department when his father fell ill. No.968, 1908–1909

Alex Reid, a probationer forester, collecting seed in exactly the same kind of hand-made paper envelopes we still use today. Paper is used for collecting 'clean' seeds (those not contained in berries) as it allows the seed to dry out without getting mouldy. Known as a "good hedge cutter", Reid was employed briefly at Benmore Estate (prior to it becoming one of our Regional Gardens), before working at the Edinburgh Garden between 1905 and 1907. He subsequently became a Forest Officer in, Tanzania. No.976, c.1905 – 1907, attrib. to D.S. Fish

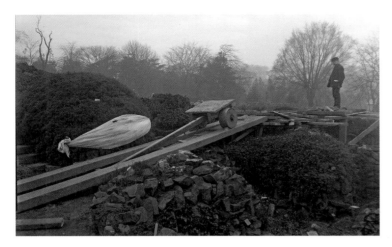

In 1908, Edinburgh's Rock Garden was reconstructed under the guidance of then Regius Keeper Isaac Bayley Balfour. In this photograph we can see the way in which large rocks were moved into place. A bag has been wrapped around a plant to protect it. ½ CN 49, c.1908–1909

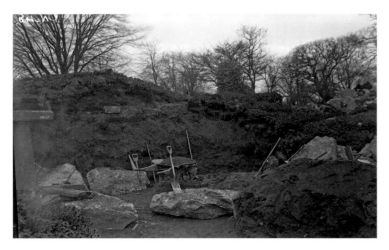

… The bulk of the stones used were conglomerates from the slopes of Ben Ledi near Callander, and red sandstone from Dumfries, freely used to suggest the impression of a rugged mountainside interspersed by valleys – a much more natural look than that of the Victorian age. ½ CN 48, c.1908–1909

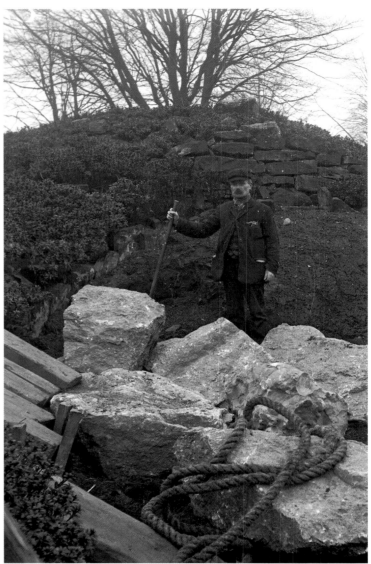

… Work continued until 1914, and there is a charming story from 1910 about the gardeners building up a large mound of earth for planting, only for Bayley Balfour to suggest that it might look better a few metres to one side. The next day was spent moving the mound until Bayley Balfour came to inspect it and decided it was better in its original position, so back it all had to go. ½ CN 50, c.1908–1909

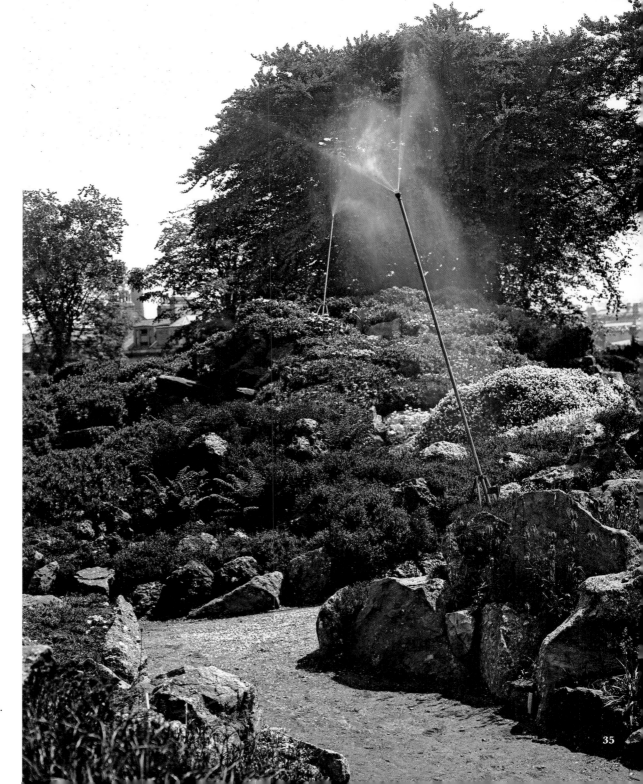

Even in Scotland's climate the plants need watering sometimes, and the Rock Garden was equipped with a series of sprays to facilitate this.

1/1 AU 44, 7 June 1911, R.M. Adam

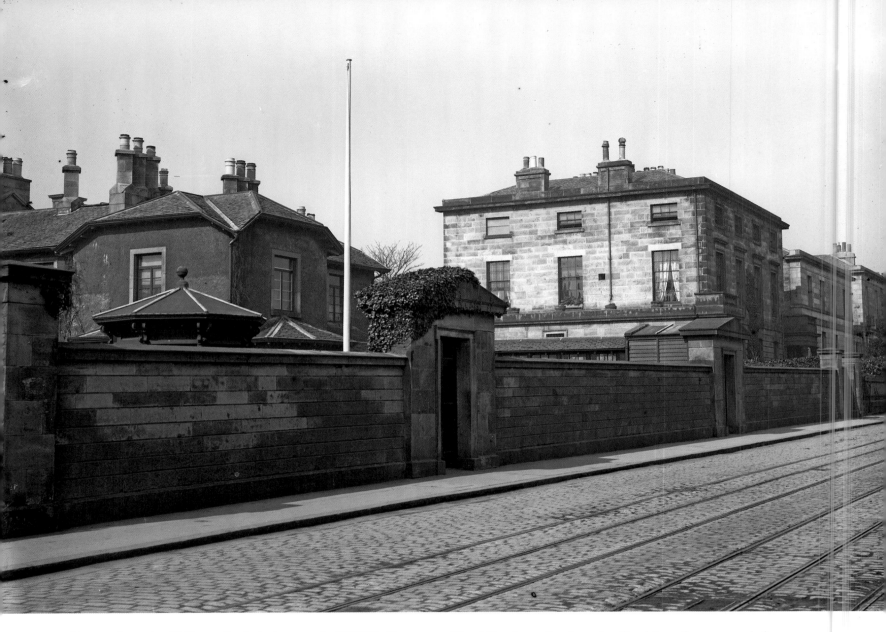

From at least the 1760s until relatively recently, RBGE's Curator, or Head Gardener, lived on site. Provision of accommodation was seen as a job perk and meant that he could be at work every day to supervise the plant care. In earlier days he was also expected to be around to sell tickets to view the Garden, a way of supplementing his salary! The house on the left behind the wall is the one built on Inverleith Row for the Head Gardener and would have contrasted sharply with the bothies located behind the Glasshouse Range that the probationer gardeners would have used.

1/1 Z 08, 6 April 1909

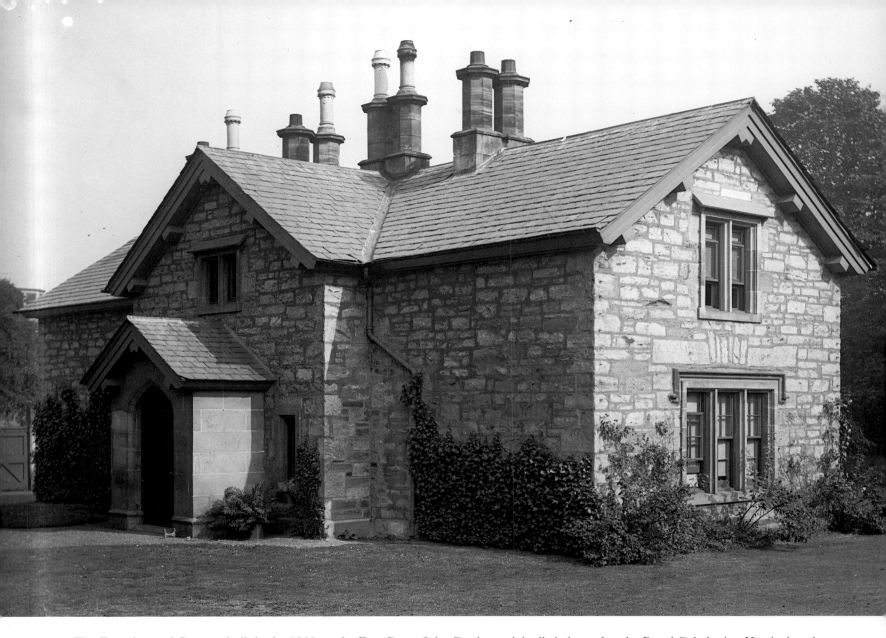

The Experimental Cottage, built in the 1820s at the East Gate of the Garden, originally belonged to the Royal Caledonian Horticultural Society (affectionately known as the 'Caley'). It was built to accommodate the Caley's Head Gardener, but in the 20th century, when the original Curator's house on Inverleith Row was swallowed up by the Laboratory buildings, it became the home of RBGE's Head Gardener. In recent years it became the home of the Regius Keeper (Director) and is now a coffee shop.

¼ FH 38, c.1900–1920, W.E. Evans

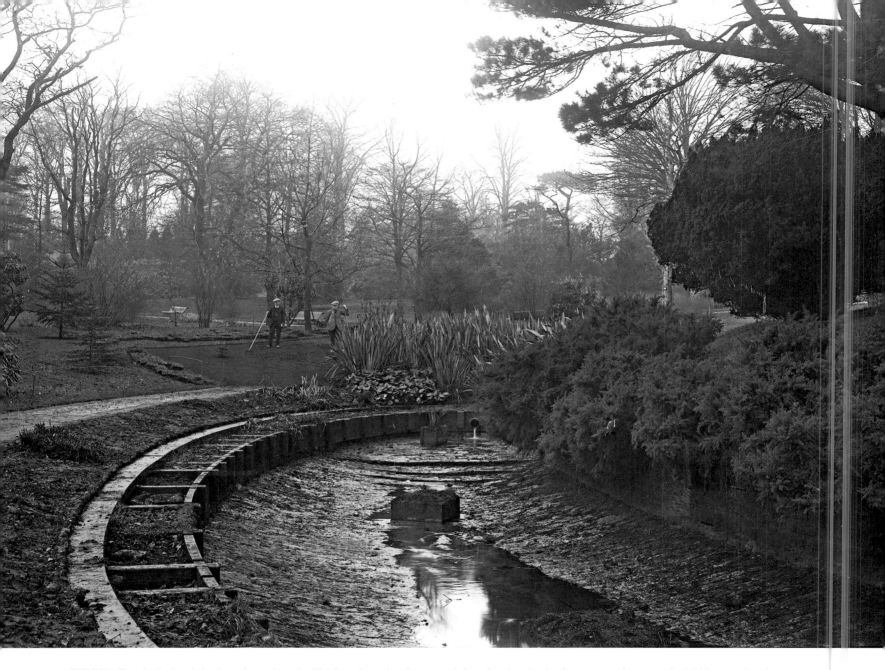

RBGE's Pond, drained during alterations in 1916 to show its shape and the planting beds along one edge, usually hidden under the water.

1/1 CB 42, 2 December 1916, R.M. Adam

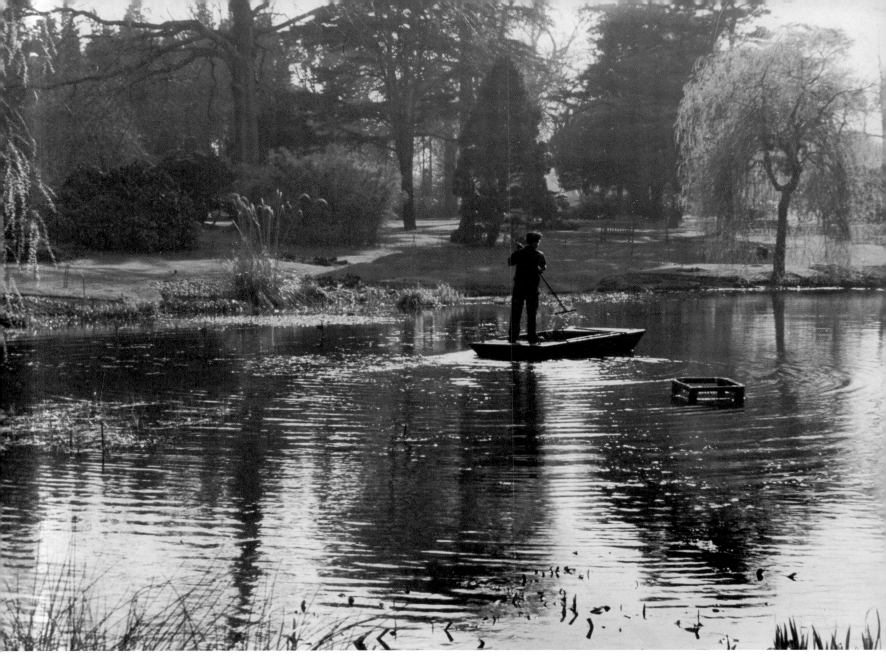

The Pond appears to have been greatly extended here – it's much wider than it was at the start of the 20th century and now requires a punt to enable the Garden staff to clear out excess pond weed with a rake. Despite a recent renovation the punt is unfortunately no longer seaworthy after sinking on its last voyage.

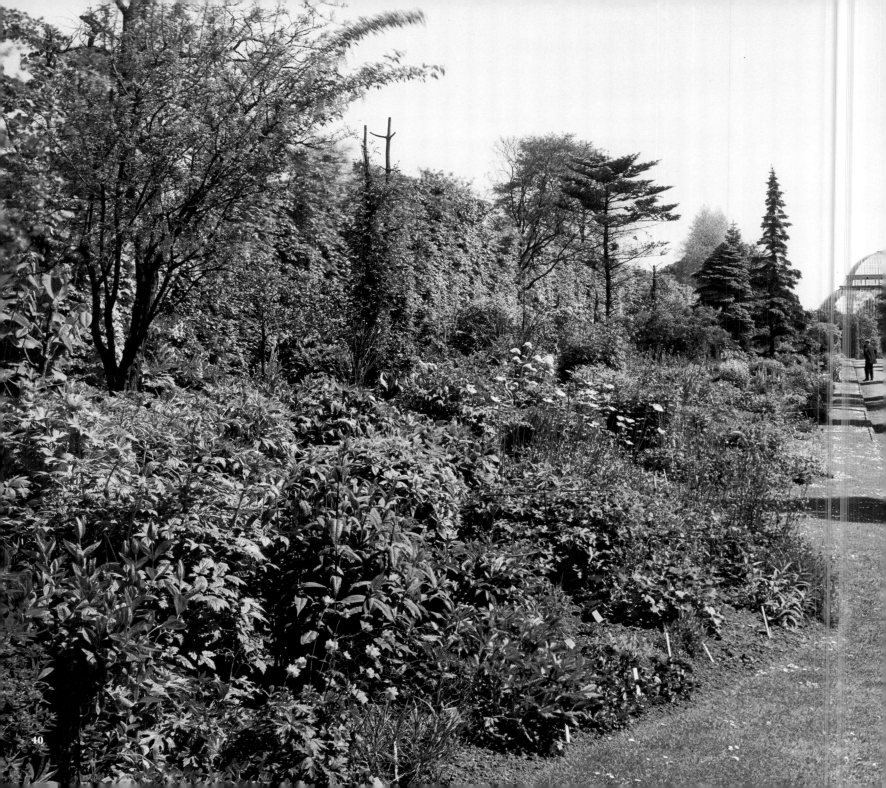

The Herbaceous Border
looking east towards the
Palm House. A riot of colour
in the summer months, the
165-metre-long border was
laid out by Regius Keeper
Isaac Bayley Balfour and
his Curator Robert Lewis
Harrow in around 1903 along
what was then the northern
boundary of the Garden.
The length of the border
was broken up and given
additional interest by hollies,
conifers and other evergreens,
and a beech hedge planted as
a background against which
the flowering plants could
be viewed. The trick with a
border like this in a botanic
garden is to include a wide
variety of plants of scientific
and horticultural merit and
interest, but also to arrange
them in such a way as to
maximise the impact of a
beautiful show.

½ BP 42, 4 June 1926, R.M. Adam

41

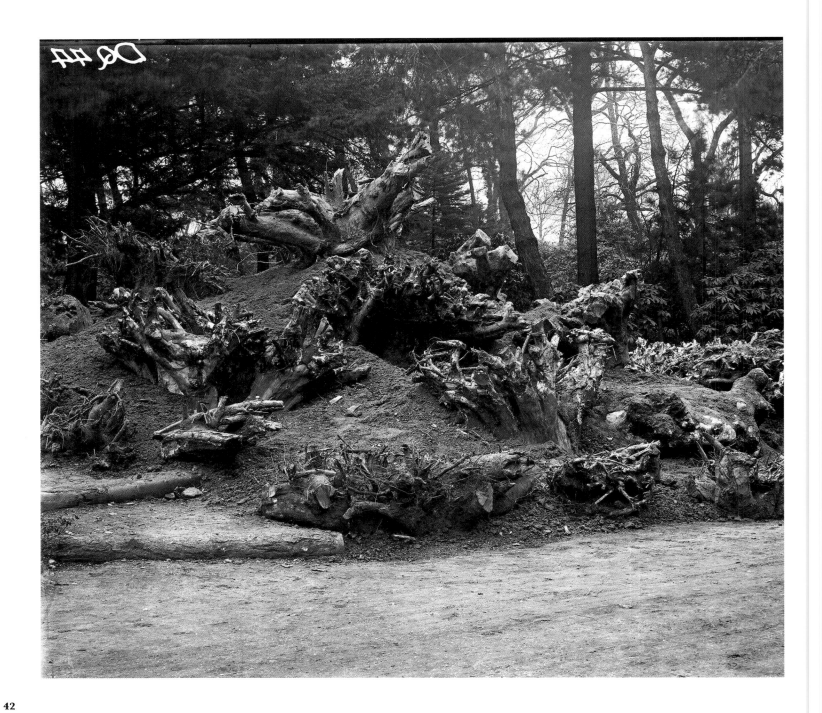

◀ Experiments with 'rooteries' or 'stumperies' were undertaken at RBGE in the 1930s. Stumperies are made by obtaining roots from hardwood trees (not conifers) which can include elm, beech, lime or horse chestnut. All the soil is cleaned from the roots and they are then arranged upside down in a mixture of peat, moss and leaf litter so that shelves and ledges are produced. New soil can then be rammed between the stumps, and the spaces between roots used for planting dwarf *Rhododendron* and peat-loving plant families such as *Gaultheria, Cassiope, Vaccinium* and various *Primula*.

1/1 DQ 44, February 1935, R.M. Adam

▶ RBGE has played host to many royal visits, but apparently King George V and Queen Mary used to appear fairly regularly when they were in Scotland. Here, Regius Keeper William Wright Smith shows the royal couple round the Rock Garden on a reasonably informal visit on 17 July 1934.

17 July 1934

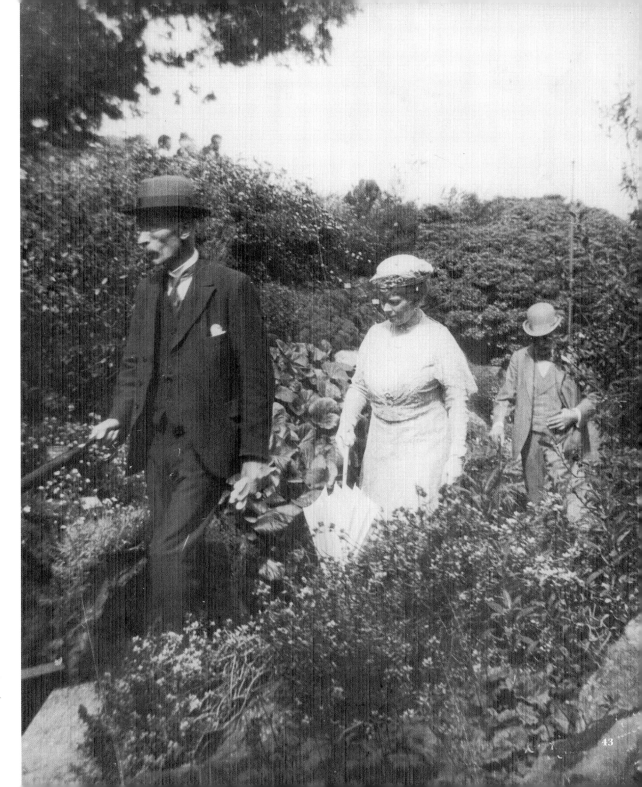

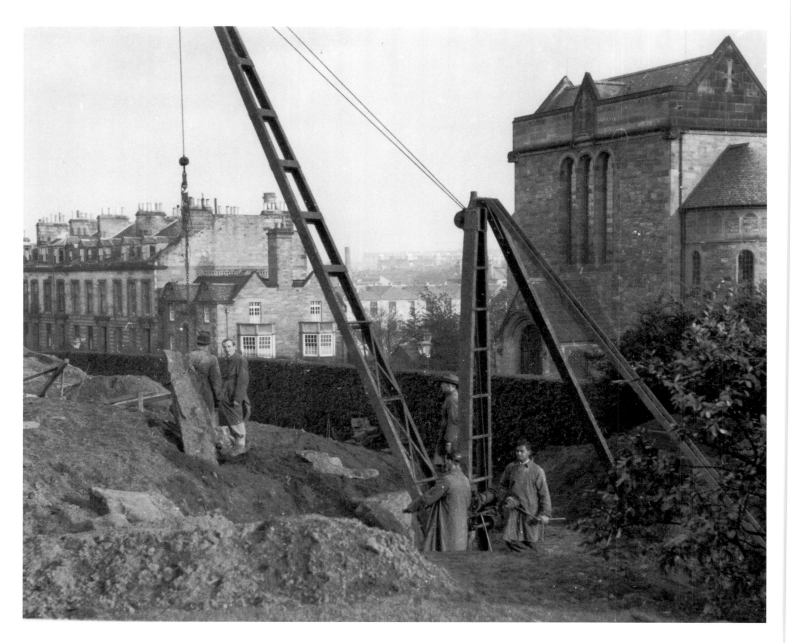

Usually some work would be done to the Rock Garden every winter but there was a major reconstruction and extension undertaken in the winter of 1937–1938. This photograph shows the equipment used to move the enormous boulders around … 1937–1938, W.G. Mackenzie collection

… and here are the new beds after having been prepared.

1937–1938, S.F. Hayes collection

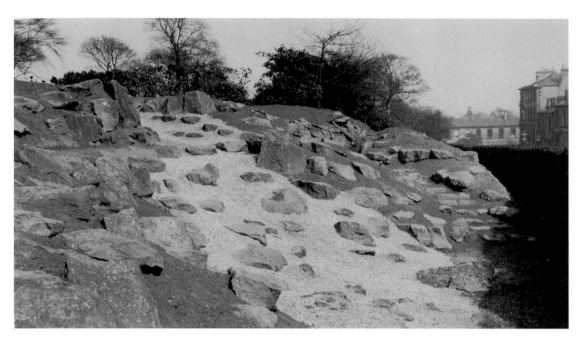

A shot of the men responsible for the major Rock Garden renovations in 1938–1939 – on the back is written "'We built a Rock Garden' students: English, Scotch, Welsh, American, Indian- International cooperation!" Unfortunately none are named, though we know that Stuart F. Hayes is on the far left and Henry (Harry) Moseley on the far right.

1937–1938, S.F. Hayes collection

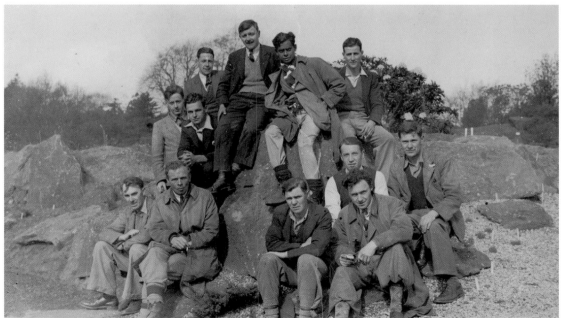

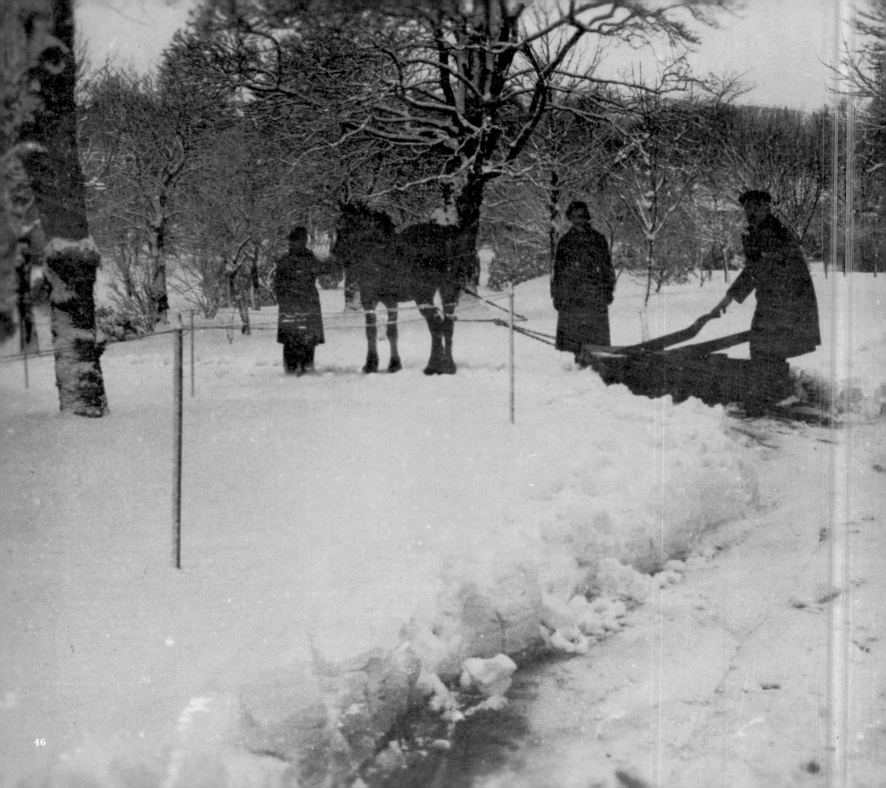

◄ Garden staff including Georgie Deans, who joined RBGE in 1926, guiding a v-shaped, horse-drawn snow plough to clear the paths in the winter of 1937.　　c.1937–1938, S.F. Hayes collection

▲ Gardeners at the West Gate entrance clearing snow by hand using brooms and besoms in 1937-8. Since the 1960s most of the snow clearing at RBGE is done by tractor fitted with a v-shaped plough, though we now have three ploughs with a variety of blades. A rubber edge helps accommodate the camber and unevenness of the paths, but it still requires a lot of patience. A hopper at the back of the tractor dispenses a grit and salt mix, although we have to be careful not to use too much salt to reduce damage to the lawns and the plant collection. Despite all this motorised help, the job often still needs to be finished by hand.　　c.1937–1938, S.F. Hayes collection

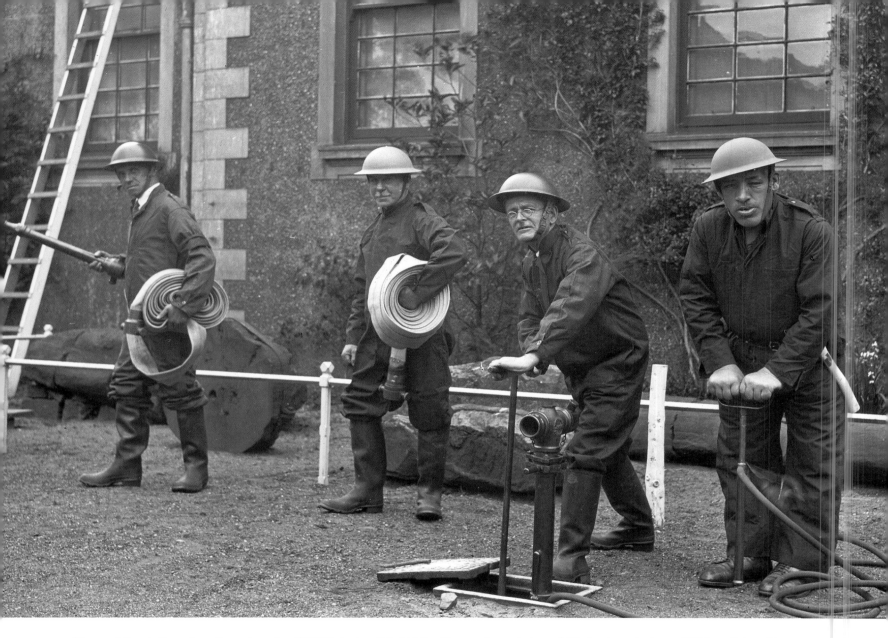

Fire and Bomb Squad no.2, stationed at RBGE during World War Two and consisting of Herbarium Assistant William Edgar Evans (3rd from left) and colleagues (left ro right) William Halley, James Shanks and James Chisholm. From 1941, a compulsory and constant watch was kept over Edinburgh from viewpoints around the Garden for fires, and various practices in case of emergency were undertaken every day. Despite Edinburgh suffering several bombing raids, and a spitfire crash in the south-east corner of the Garden in September 1941, the services of the Fire and Bomb Squad were apparently never required, at least certainly not in a blitz situation. 26 June 1942, W.E. Evans collection

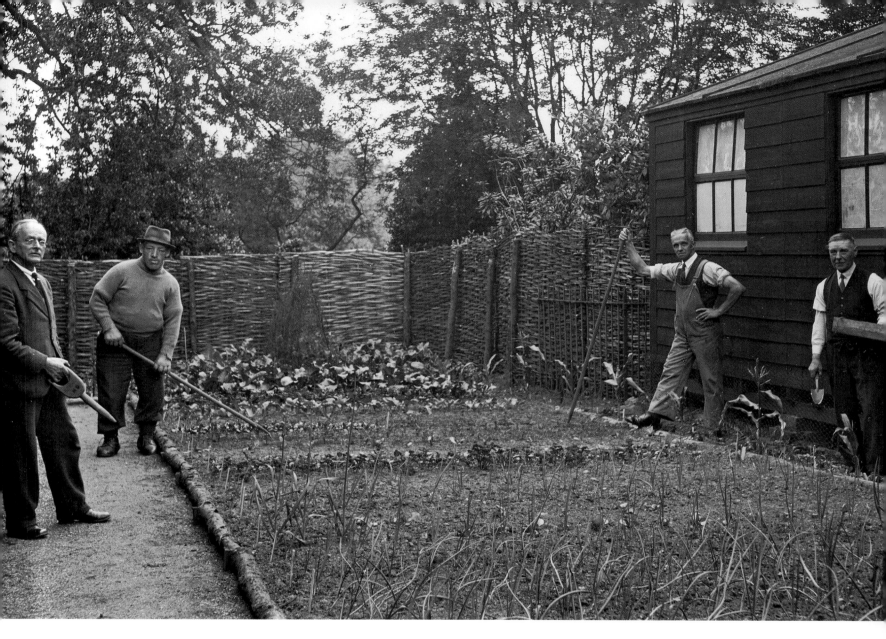

In their spare time, the members of Fire and Bomb Squad no.2 manned their allotment producing vital food supplies in times of need.

26 June 1942, W.E. Evans collection

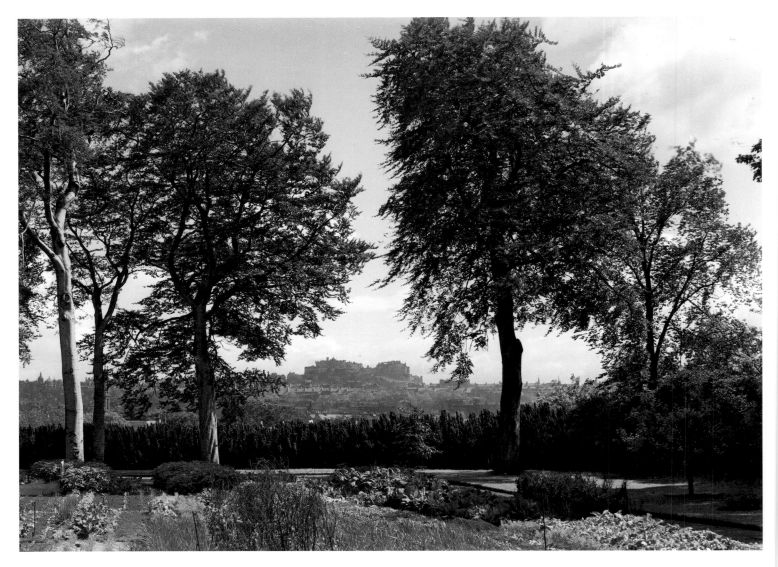

A photograph which encapsulates two ways of dealing with warfare through the ages – Edinburgh Castle on the skyline symbolising fortification and, in the foreground, the lawn in front of Inverleith House which has been given over to allotment space to produce much-needed vegetables during World War Two. It may well be that, like today, visitors could go to the RBGE allotments for advice on starting and maintaining their own. This photograph was taken on 27 June 1943 by Robert Moyes Adam, who was no stranger to warfare having served with the Royal Garrison Artillery and Royal Air Force in World War One, eventually doing much vital reconnaissance and training work with aerial photography.

½ FH 30, 27 June 1943, R.M. Adam

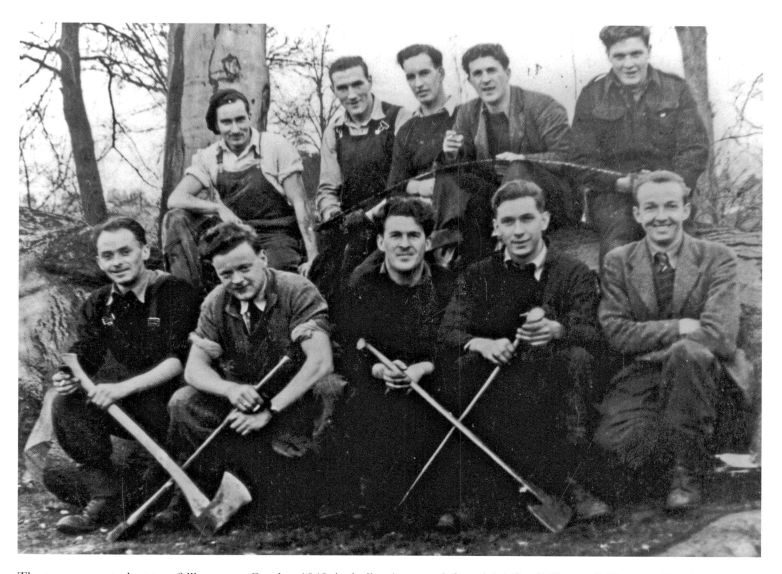

The temporary student tree-felling team, October 1949, including (top row, left to right) Geoff Turner, S. Houston, Jim Brumfitt, Donald (Danny) Patience and Bill Brown; and (bottom row) George Shaw, John Livingstone, Jimmy Patience, Marshall Morrison and Alf Evans. All were probationer foresters or gardeners except for Alf, a former probationer, but at that time Foreman of the Outdoor Department and in charge of the tree-felling operation. He took this photograph using a delayed shutter switch – quite an innovation in those days.

October 1949, Alf Evans

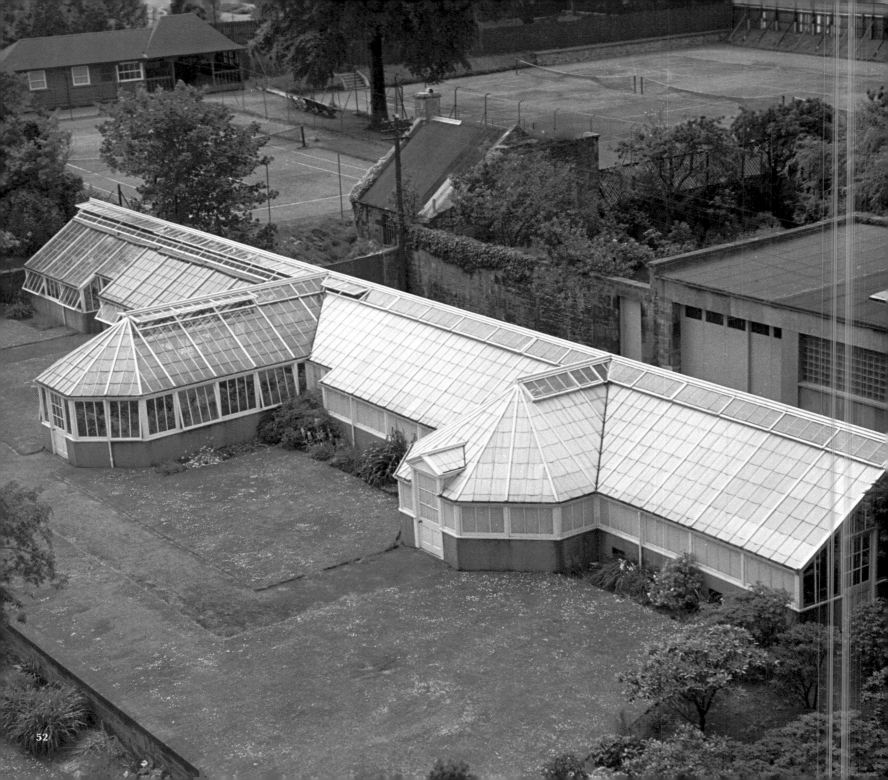

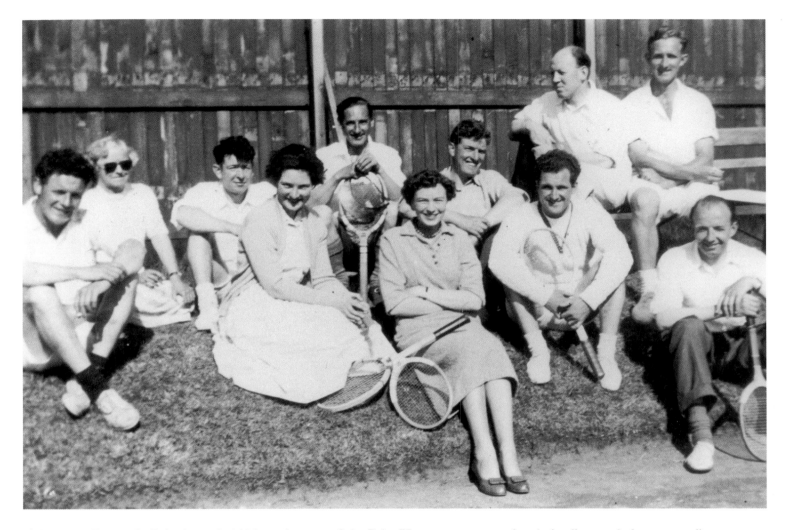

◄ The West Range, built in the early 1950s to the west of the Palm House to accommodate 'miscellaneous' plants according to our 1952 Guide Book, including alpine and Mediterranean plants, and plants of "biological interest" – a curious description! The house was demolished in 1974 and replaced by the Alpine House. In the background are the tennis courts which for a time were used by RBGE staff to keep fit and undoubtedly blow off a bit of steam. This area became the Silver Garden in 1979 and the Queen Mother's Memorial Garden in 2006.

c.1950s

▲ Wimbledon here we come! Some of RBGE's staff enjoying the tennis courts in the early 1950s including outdoor Foreman Alf Evans on the far right and, second from left, Lottie Littlejohn, who started at RBGE during World War Two, quite possibly as part of the Women's Land Army.

Early 1950s

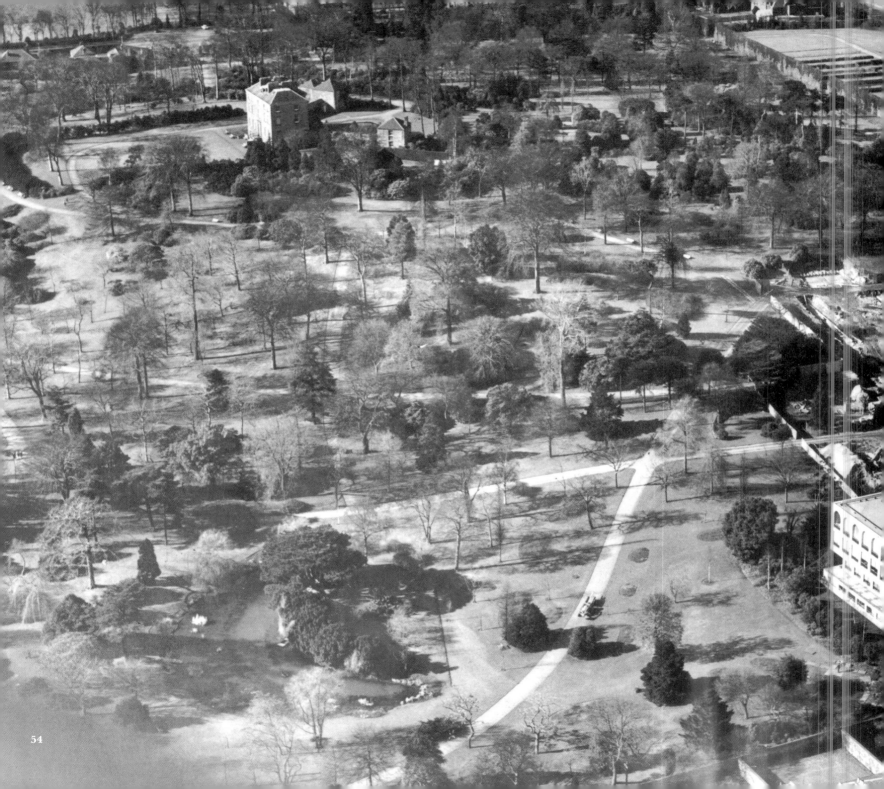

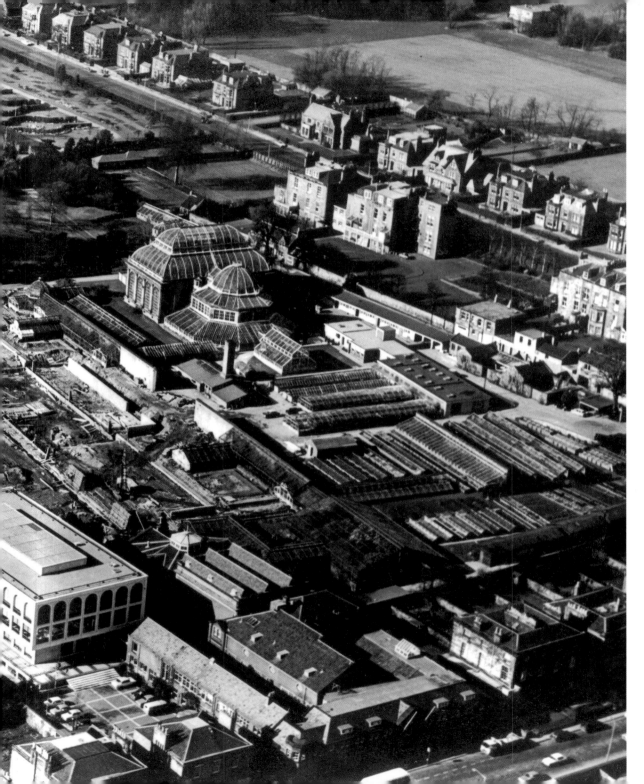

An aerial view of most of the Garden in 1965, taken whilst the old Glasshouse Range was being demolished. There seems to be less tree cover in this image than there is today, possibly as there are few leaves on the trees, but more likely because the trees are so much larger now. The yew hedge can still be seen curving around the lawns in front of Inverleith House on the centre left of the photograph – a reminder of the fact that the house was, from the late 1870s to 1956, the official private residence of the Regius Keeper. No longer needed as a residence after William Wright Smith's death, it became the Scottish National Gallery of Modern Art in 1960 under Harold Fletcher's tenure as Regius Keeper, bringing a whole new audience in to enjoy the Garden.

1965

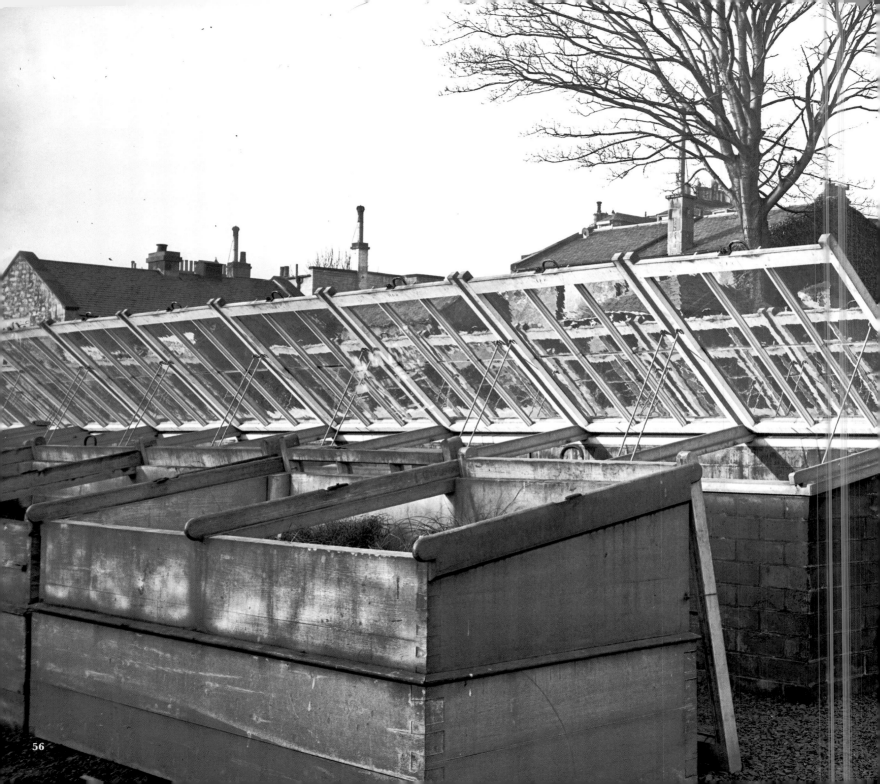

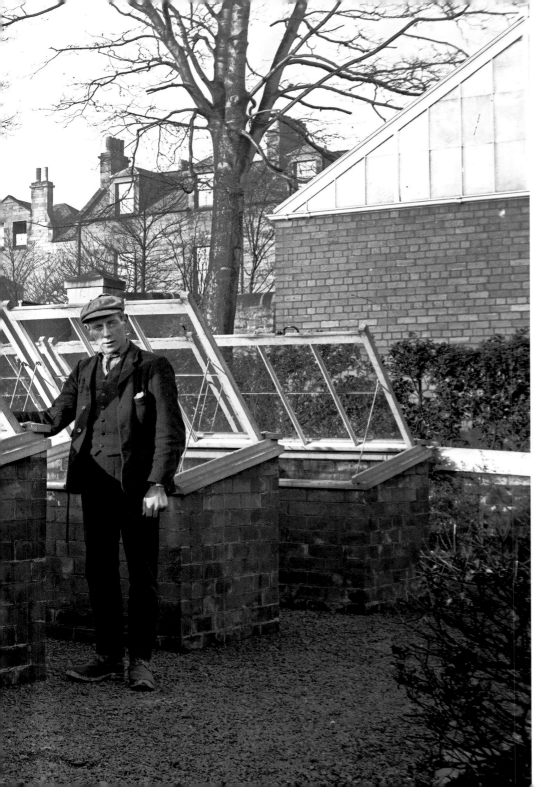

Sowing and Growing

In general, our Horticulture Department has always been split into two main divisions, 'Outdoor' and 'Indoor', but both can be united by at least one thing – propagation. Usually this work is done behind the scenes in the area behind the Glasshouses, or in the Nursery located a small distance to the north of the Garden itself. In this section we have selected a variety of images that show what these areas look (or looked) like, and many of the different stages involved in skilfully producing the beautiful and varied plants on show in the Garden and Glasshouses. Many of the processes here are exactly the same today as they were a century ago and even further back.

½ CK 06, c.1900–1906, D.S. Fish

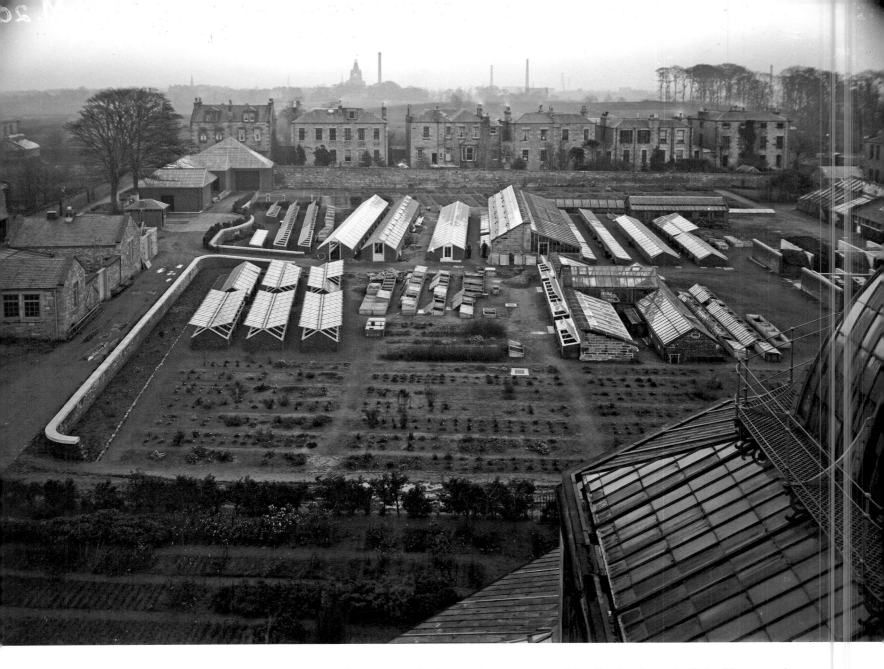

Two comparative shots showing the Propagation Department in the north-east corner of the Garden from the Palm House roof at the start of the 20th century, and the same area in the mid-1970s by which time it had become a large complex of research and quarantine glasshouses.

½ CM 20, c.1900–1906, D.S. Fish

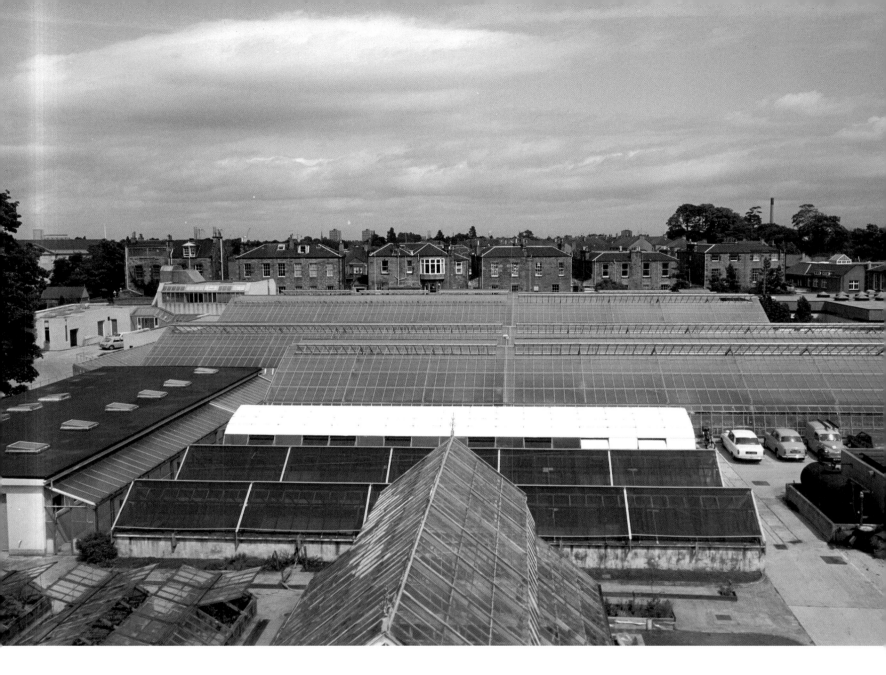

IMG-407, c.1970s

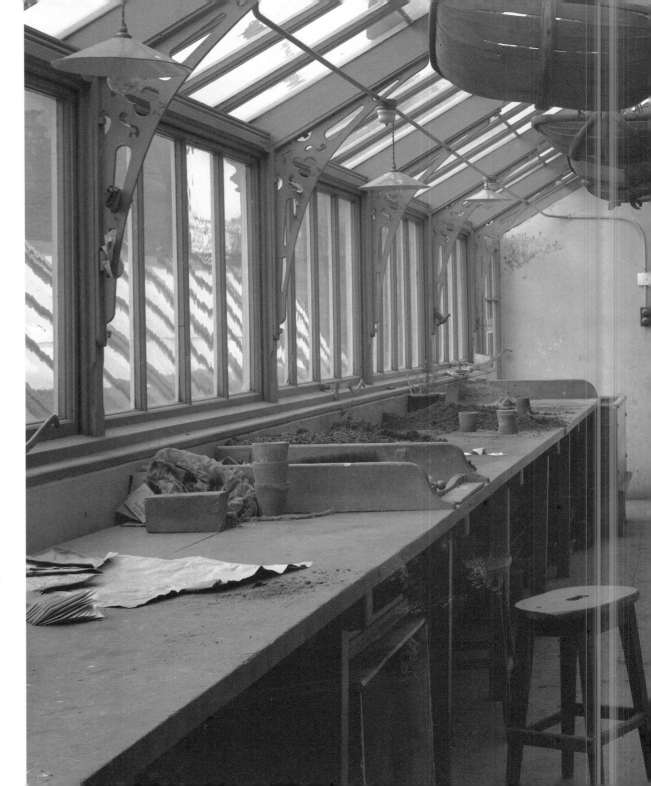

The Herbaceous
Department's potting shed at
the start of the 20th century,
containing all the elements
still existent in our potting
sheds today, although we
no longer have the glass
roof which would have
flooded the room with light.

½ CM 19, c.1900–1906, D.S. Fish

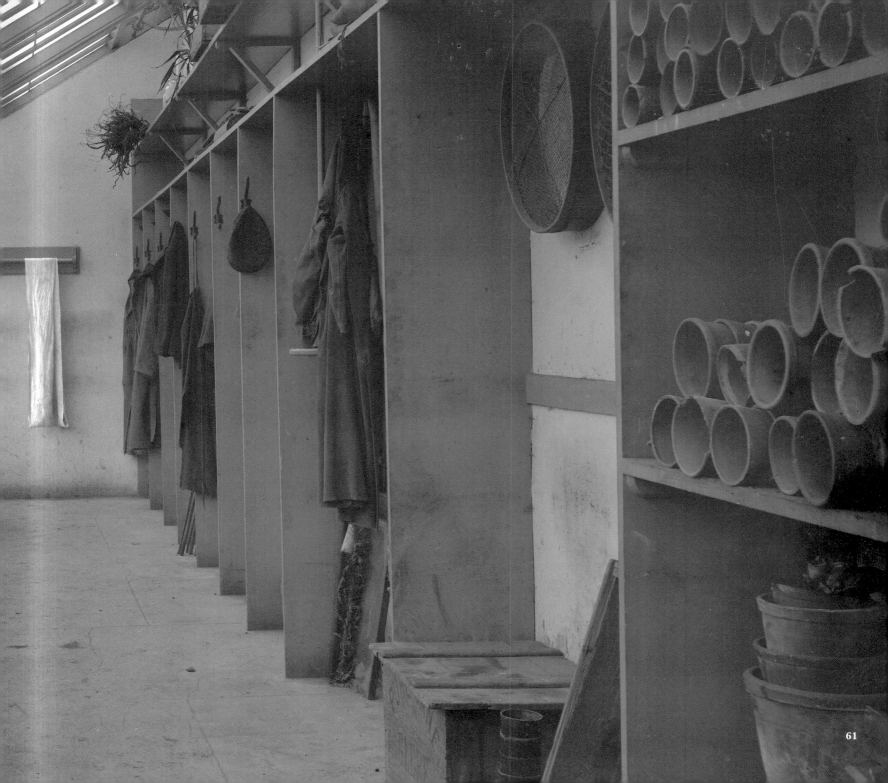

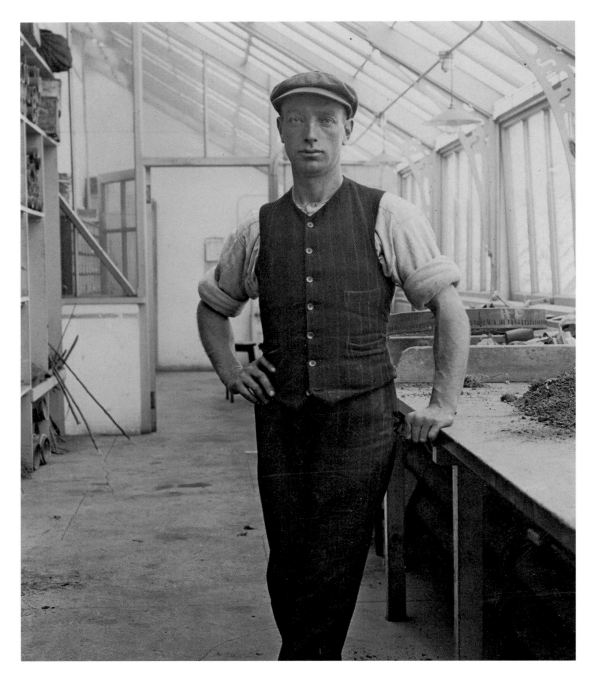

A gardener in the potting shed, quite likely planting seeds as he seems to have been sieving compost in the background.

No.958, c.1904–1906, attrib. to D.S. Fish

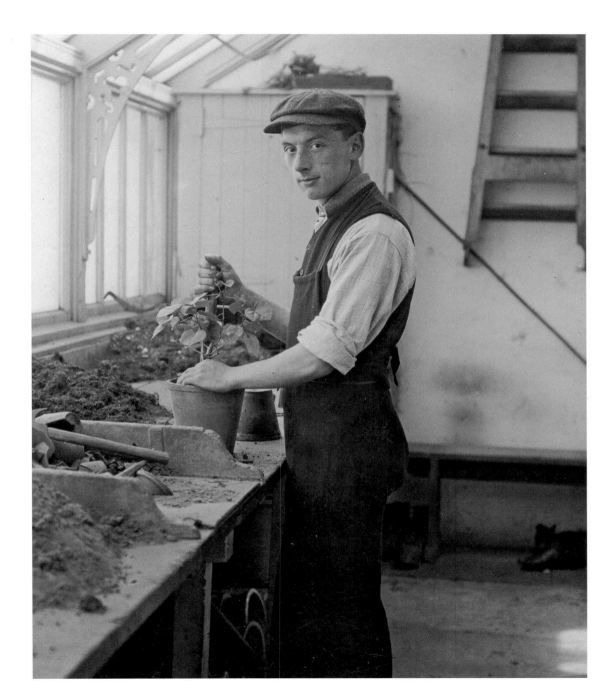

A gardener in the potting shed transferring a more mature plant specimen into a larger pot.

No.961, c.1904–1906, attrib. to D.S. Fish

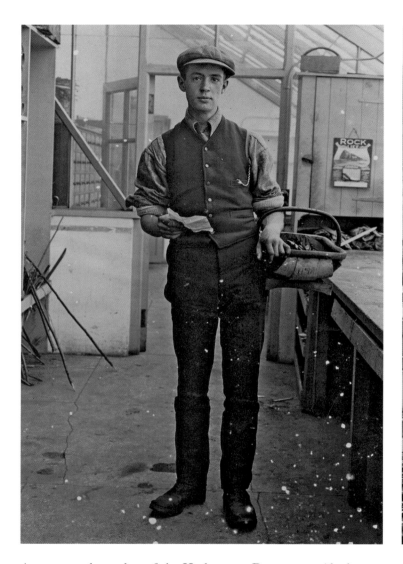

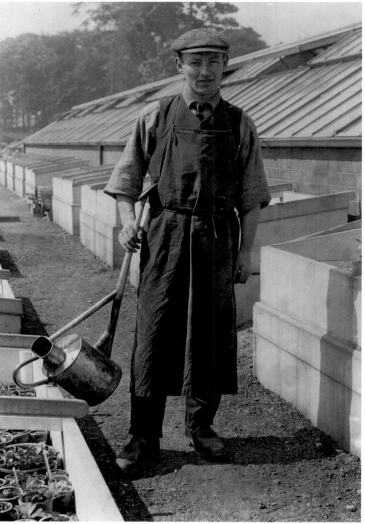

An unnamed member of the Herbaceous Department (the letters H.D. are on the front of his trug) attending to an errand in the potting shed around 1905.

No.959, c.1904–1906, attrib. to D.S. Fish

A gardener by the cold frames with watering can and, like many of the horticultural staff at this time, wearing traditional clogs. With wooden soles and leather uppers they were the steel toecaps of their day.

No.937, c.1904–1906, attrib. to D.S. Fish

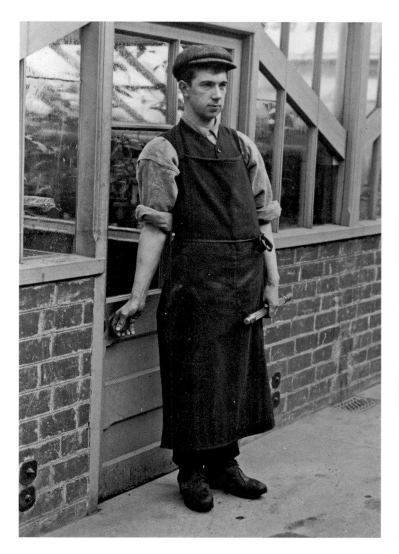

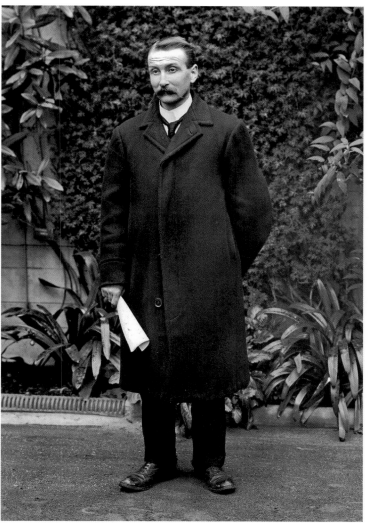

A gardener emerging from one of the pit houses. These were glasshouses sunk into the ground, sometimes by as much as a metre, to protect the house from wind chill and maintain a cooler environment during the warmer months. This gardener is holding a fountain pump or mister in his hand, which could have been used to humidify the plants, or, more likely, for pest control.

No.953, c.1904–1906, attrib. to D.S. Fish

Laurence Baxter Stewart, Foreman of the Glass Department in 1910 when this photograph was taken. Stewart had a phenomenal reputation as a 'botanical wizard'. He eventually became Head Propagator and was noted for being able to produce plants from 'impossible' cuttings such as those taken from pine trees, something textbooks of the day claimed could not be done. "You must know your plants, and be able to go up and say 'Good morning, So-and-so.'"

½ AH 45, November 1910, R.M. Adam

65

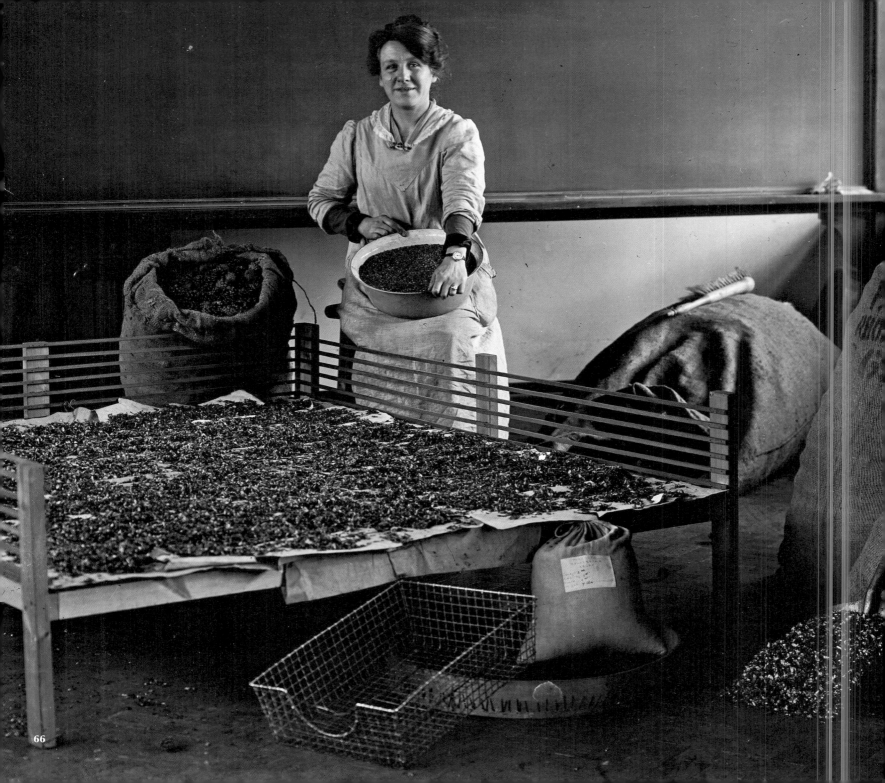

A massive pine cone drying operation to obtain seeds, carried out at RBGE immediately after and quite likely during World War One by Miss McQueen, who was possibly from what was to become the Forestry Commission. It is likely that experiments in producing large quantities of wood quickly, perhaps as part of the War or post-War effort, were being undertaken.

1/1 CE 11, 29 March 1919, R.M. Adam

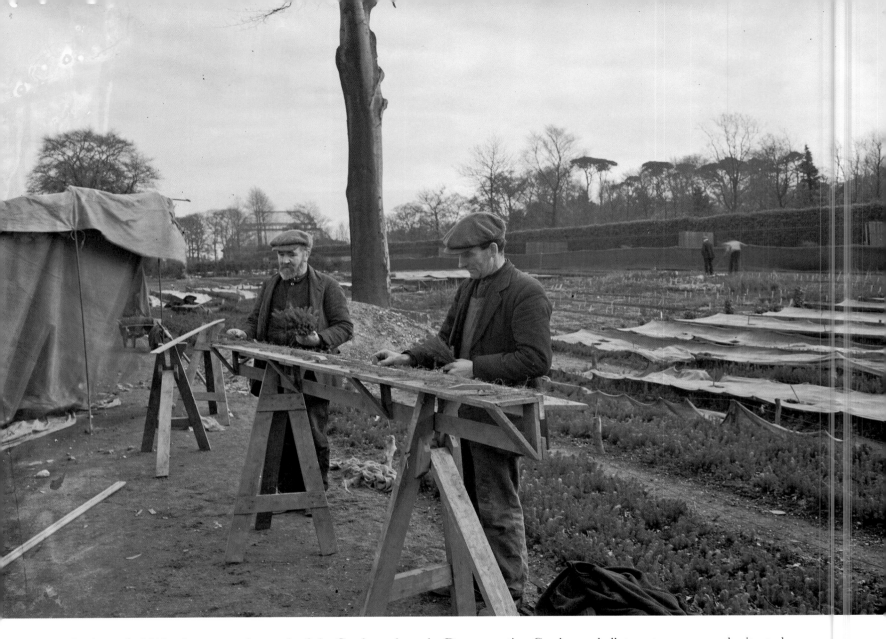

In the early 1920s, the area to the north of the Garden, where the Demonstration Garden and allotments are currently situated, was leased from the Fettes Trust to become the nursery for the Forestry Commission, essentially an area to conduct scientific trials in the production of trees. It had been a meadow for grazing cattle. This photograph is the first in a series demonstrating what is referred to in the photography register as the "Murthly Method" of planting conifer seedlings. First, the seedlings are laid into grooves on a 'planting board' …

½ BM 40, 27 March 1925, R.M. Adam

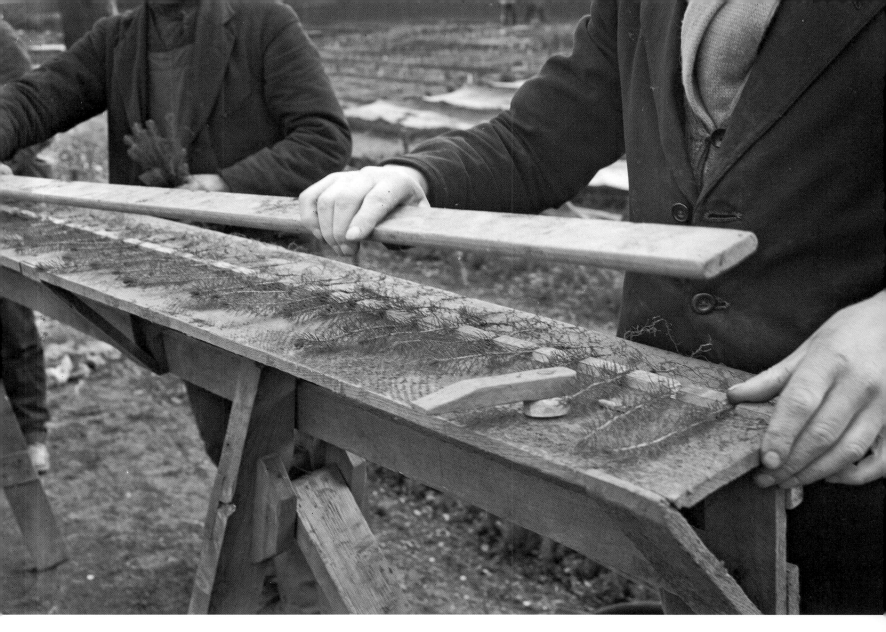

... and then they are fixed in place with a wooden strip ...

½ BM 39, 27 March 1925, R.M. Adam

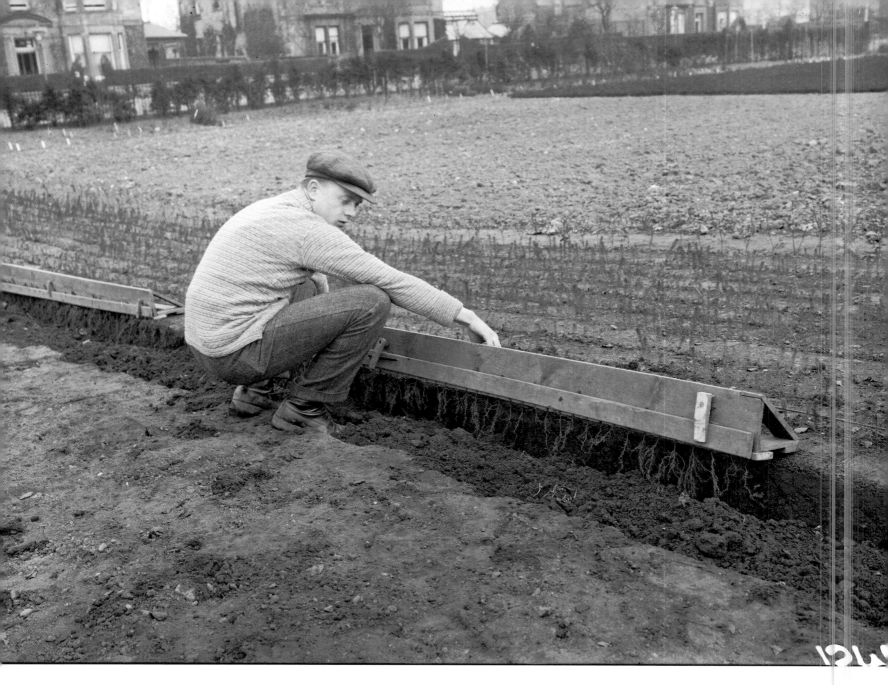

… the whole planting board is then turned over and placed adjacent to a trench …

½ BM 49, 28 March 1925, R.M. Adam

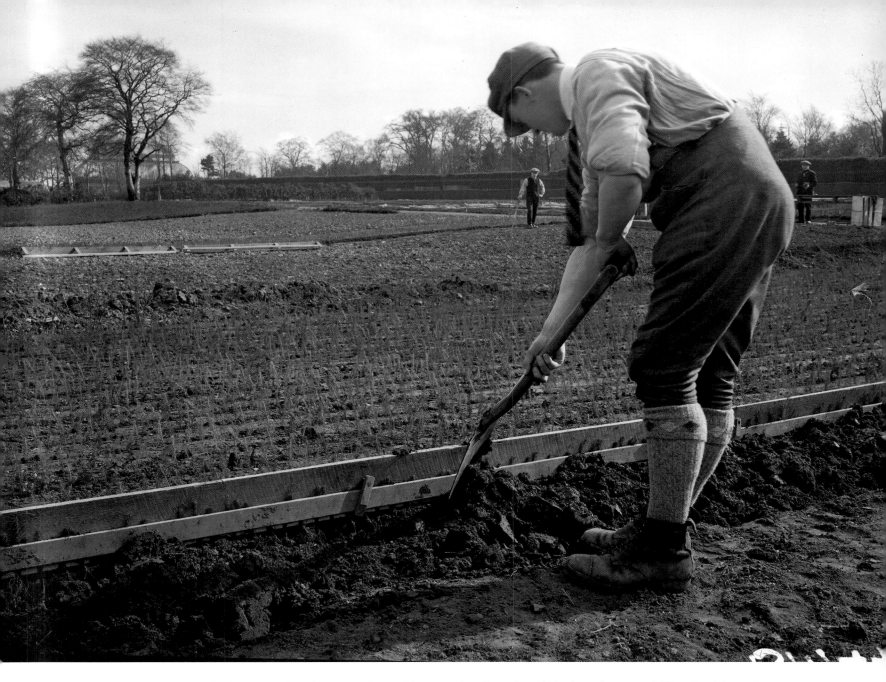

… the trench is then earthed up, covering the roots, the seedlings are 'unclipped' and the board removed. You should now have a row of perfectly spaced out conifer seedlings.

½ BM 44, 27 March 1925, R.M. Adam

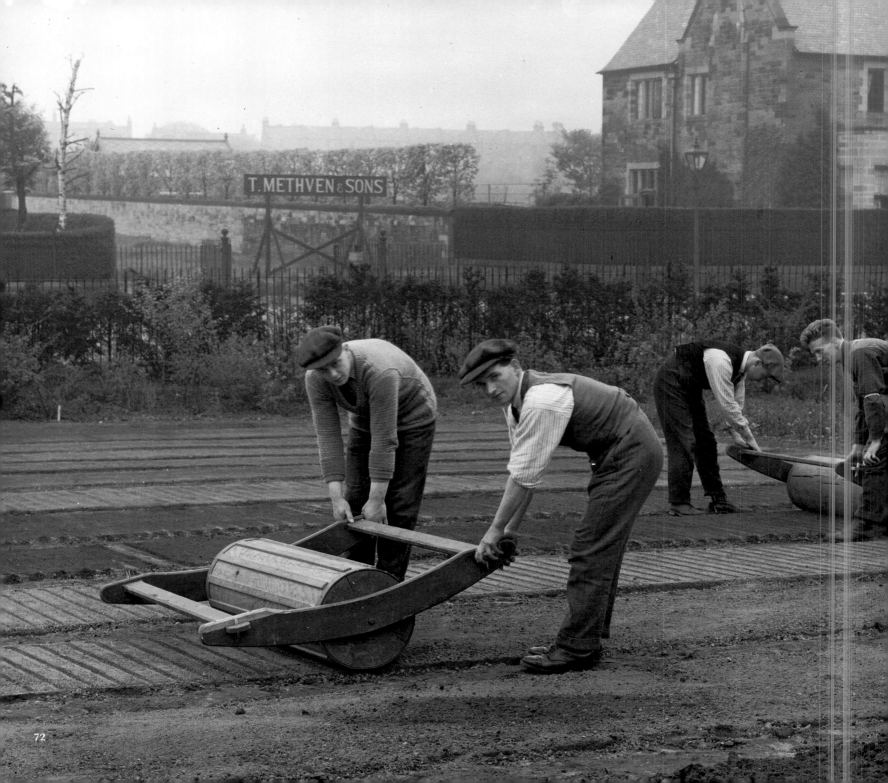

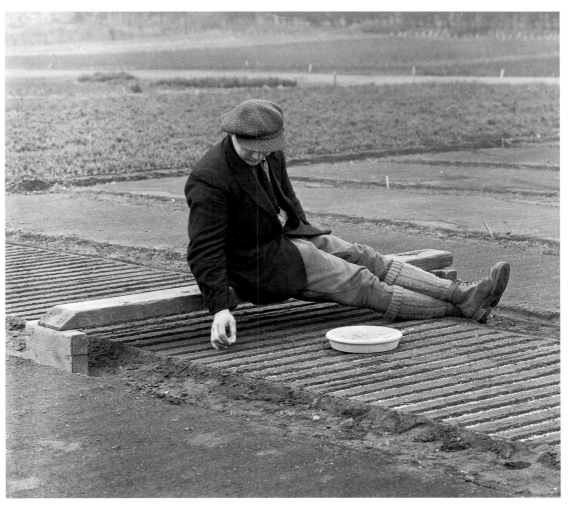

◄ Here are some more trials taking place in the Forestry Nursery in the north of the Garden – seed beds are being quickly prepared by pulling a roller with batons attached to it over a strip of land to produce drills.

½ BN 26, 21 May 1925, R.M. Adam

▲ Different ways of planting up the prepared drills were experimented with – here a man sits on a raised plank and sows by hand. Mass production of trees at RBGE was a Forestry Commission operation, and not something done specifically by RBGE, but we had close ties with the Commission when it first started in the 1920s, and many of the trials were of benefit to the Garden and its Arboretum.

½ BN 32, 22 May 1925, R.M. Adam

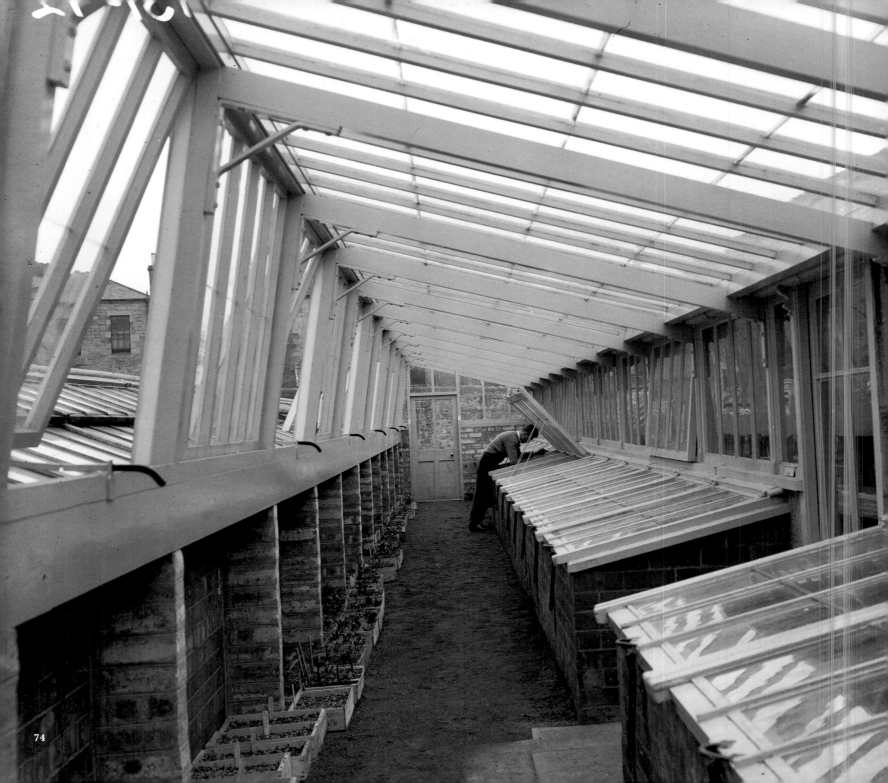

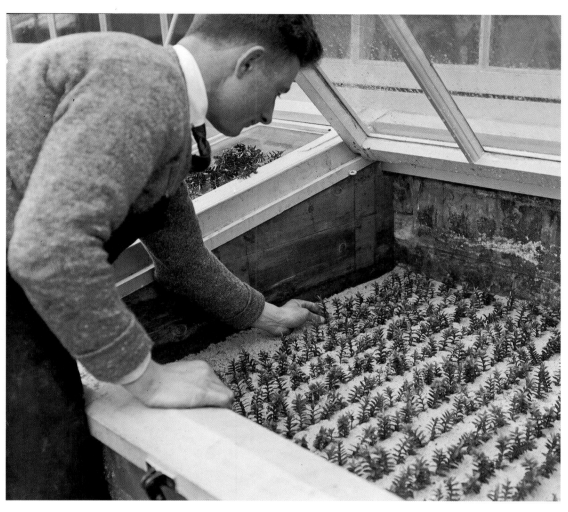

◀ A photograph of a recently erected glass corridor situated beside the Herbaceous Department's potting shed in 1926. It contained the cold frames constantly used for the propagation of plants. But why put a roof over external frames? Anyone who has ever worked with young plants in the wind and rain might know the answer to that – it is likely that the roof gave additional protection to fine seeds or fragile seedlings being moved from shed to frames. ½ BP 12, 8 April 1926, R.M. Adam

▲ This man is demonstrating the process of inserting freshly obtained *Hebe* cuttings into a frame of compost and sand where they should eventually take root. He has a small pile still to do on his left, but would be cautioned today for not keeping them hydrated! ½ BP 05, 8 April 1926, R.M. Adam

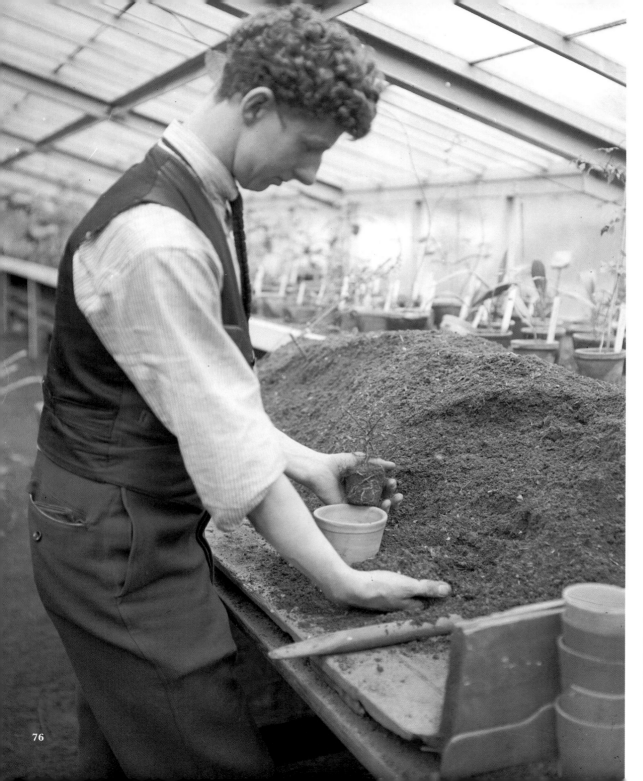

This man looks only too keen to carry on with his task of repotting a successfully rooted cutting after pausing to have his photograph taken.

½ BP 14, 8 April 1926, R.M. Adam

A man demonstrating a house of pots containing germinating seeds on 8 April 1926. From the labels that can be read we know that at least some of these pots contain *Rhododendron* seeds collected by the legendary Scots plant collector George Forrest and his men in mid-west Yunnan, China, in November 1925, only five months earlier.

½ BP 09, 8 April 1926, R.M. Adam

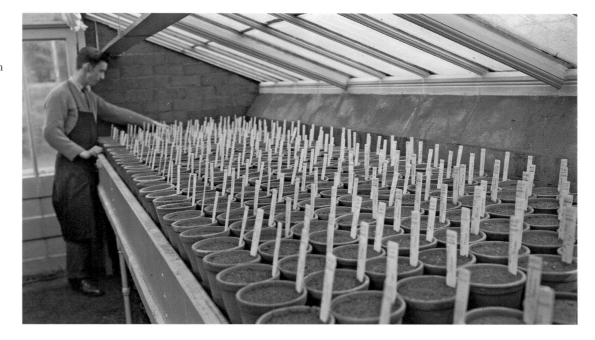

This glasshouse contains pots of healthy, thriving seedlings including species of *Aster*, *Alonsoa*, *Althaea* and *Crepis*.

½ BP10, 8 April 1926, R.M. Adam

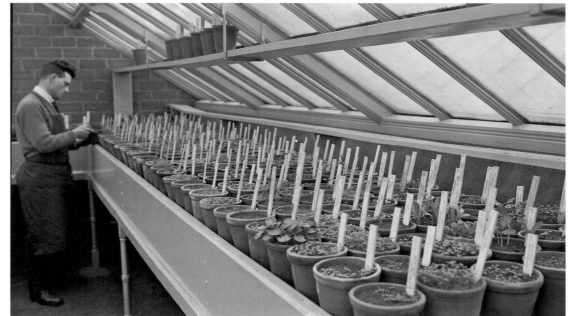

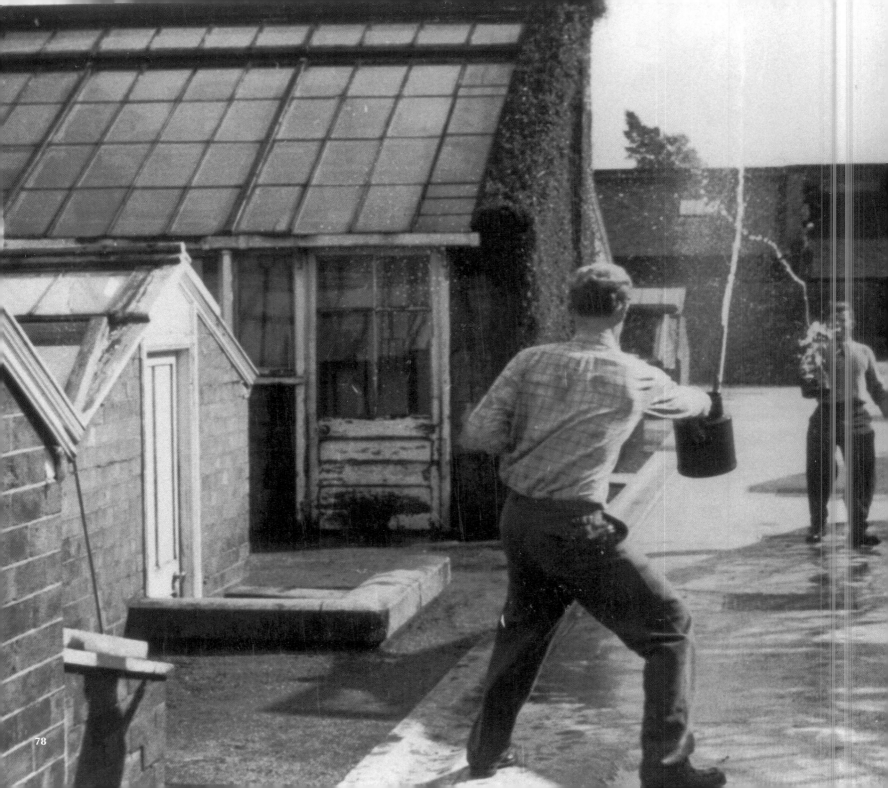

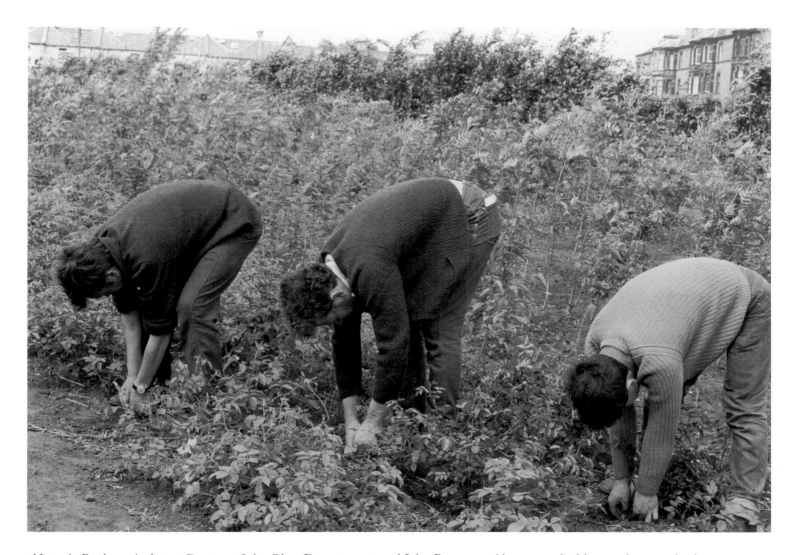

◀ Lawrie Buchan, Assistant Curator of the Glass Department, and John Bryan mucking around with watering cans in the Propagation Department in the 1950s, proving that it wasn't all work and no play!

c.1951–1960

▲ Donald Morrison, Colin Bloomfield and Ron Rutherford (left to right) hard at work in the RBGE Nursery, situated a short distance to the north of the Garden. It appears that they might be layering *Rubus*, or brambles, by wounding and staking branches into the ground to encourage new root growth, thus producing new plants. The Nursery was acquired from the Fettes Trust in 1958, providing RBGE with ample space 'behind the scenes' to produce plants and turf for use in the Garden, as well as much-needed research space.

c.1968–1969

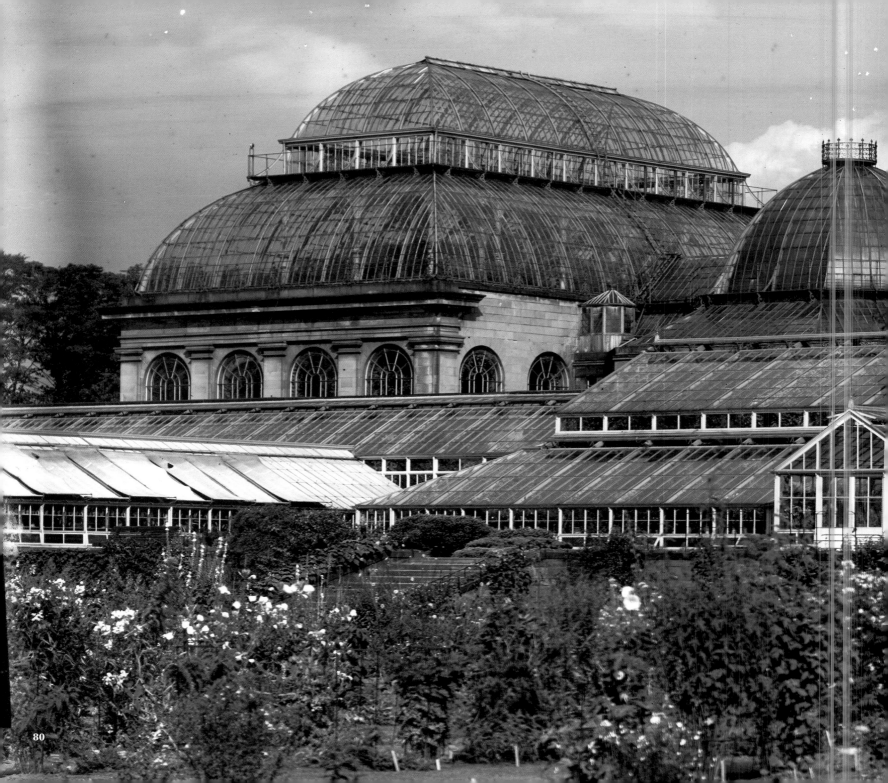

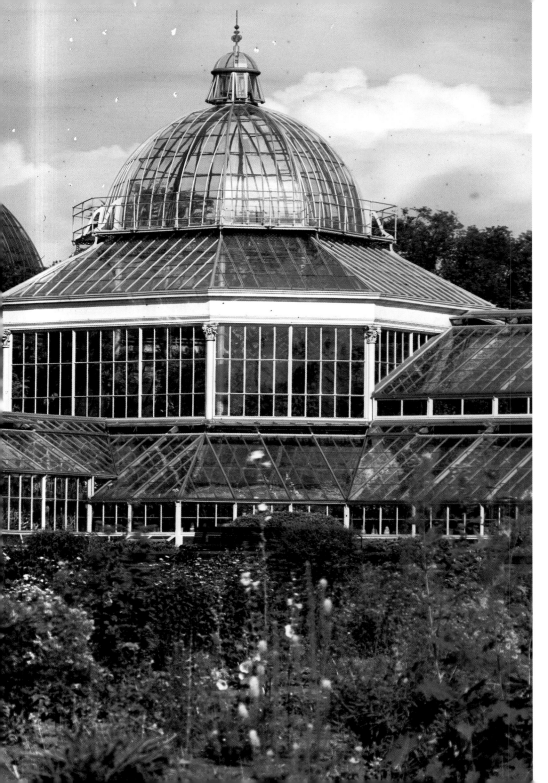

Life Under Glass

Perhaps the greatest change over the last 150 years at RBGE has been in the appearance of our Indoor Department. Even the iconic Temperate Palm House, which looks much the same from the outside today as it always has, has had many changes inside. The Glasshouse Range, located to the south of the Palm Houses, has undergone many transformations, being partly demolished and rebuilt a few times until the 1960s when it was completely replaced by the more modern Glasshouses still here today.

The insides and the workings of the Glasshouses have changed as much as the outsides. The aim of this section of the book is to take a small tour through some of the Victorian-era displays and some of the 20th century changes, and, of course, to meet a few of the horticulturists whose job it was to keep everything thriving under the glass.

1/2 CJ 06, c.1900–1906, D.S. Fish

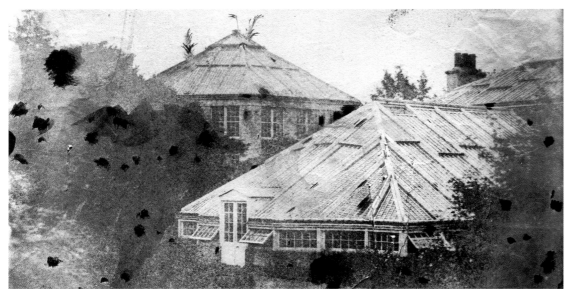

This is thought to be the oldest photograph in the archives at RBGE, a salt print taken by Dr James Duncan in around 1855. It shows today's Tropical Palm House and west end of the Glasshouse Range. The palm trees have broken through the old roof of the house and this image was successfully used to secure funding from Parliament to build what is now the Temperate Palm House, directly in front of the older house.

c.1855, Dr James Duncan

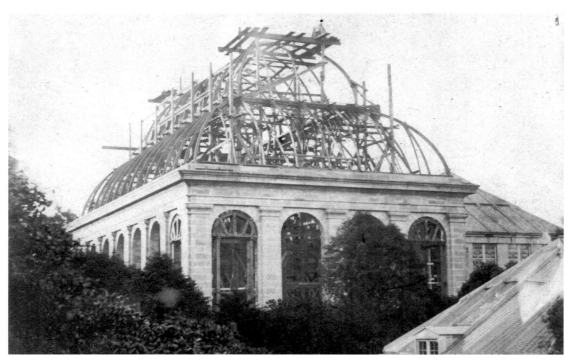

This photograph, probably taken mid-1857 by an unknown photographer, shows the Temperate Palm House under construction. The walls appear complete, the iron work of the roof is well under way and presumably the job of installing the glass is about to begin. The building was eventually opened to the public on 1 April 1858.

Mid-1857

The Sabal palm (*Sabal bermudana*), photographed in the centre of the Tropical Palm House early in November 1874. It is looking good despite its recent 'retubbing' and move from the Temperate Palm House next door. Over 50 years prior to this it had been one of the plants transported from the Botanic Garden's previous site on Leith Walk. It was eventually removed from its tub and planted into the ground of the Tropical Palm House at the beginning of the 20th century, and still remains there to this day.

November 1874

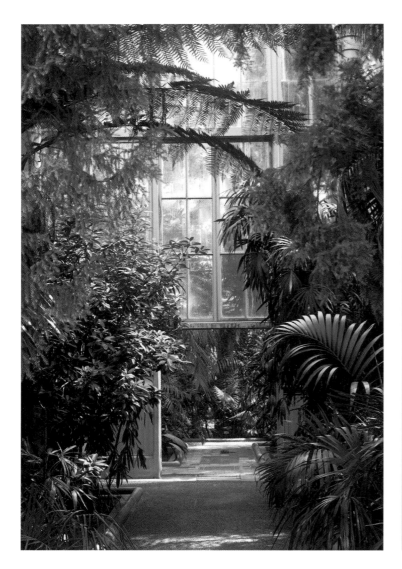

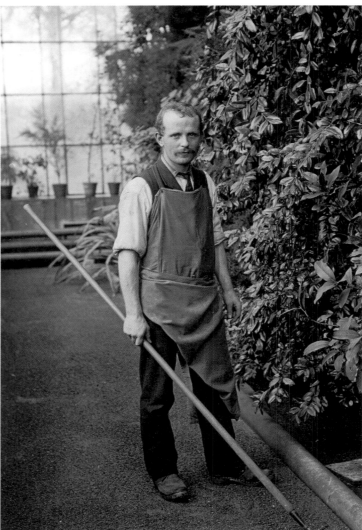

The view from the Temperate Palm House into the Tropical Palm House as it would have been at the turn of the 20th century. The windows which formed the partition could be folded back and the bar underneath removed to allow the movement of large plants between the two houses – a useful feature in a palm house.

1/1 M 12, c.1900

James Douglas McKenzie worked in RBGE's Glass Department as a probationer gardener between 1903 and 1907. Despite his training and new qualifications, and the fact that he came from gardening stock, he was unable to gain employment in horticulture on leaving, becoming a motor car driver in Edinburgh.

No.941, 1903–1907, attrib. to D.S. Fish

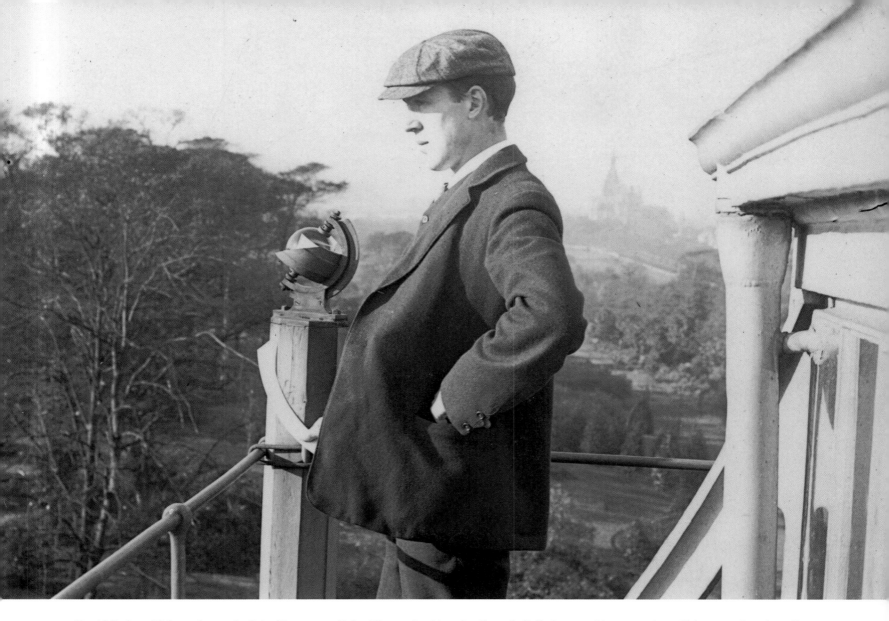

David Sydney Fish on the roof of the Temperate Palm House checking the Campbell-Stokes sunshine recorder, still in use today. Any direct sunlight is magnified by the sphere, scorching a recordable trail on the card behind it. Nowadays, this information is retrieved by members of the Indoor Department. Fish started as a probationer gardener at RBGE at the age of 15 in 1896. By 1903, he had been promoted to Foreman of the Herbaceous Department and was tipped for great success in the future by Regius Keeper Isaac Bayley Balfour. The latter admired not only Fish's horticultural skill and his photography at a time when RBGE had no official photographer, but also his "facile pen" – Fish wrote articles and authored a book. He left RBGE at the end of 1906 to become the Secretary and Superintendent of the Horticultural Society in Alexandria, Eygpt, where he died of typhoid fever in 1912 at the age of 31.

No.935, c.1904–1906, attrib. to D.S. Fish

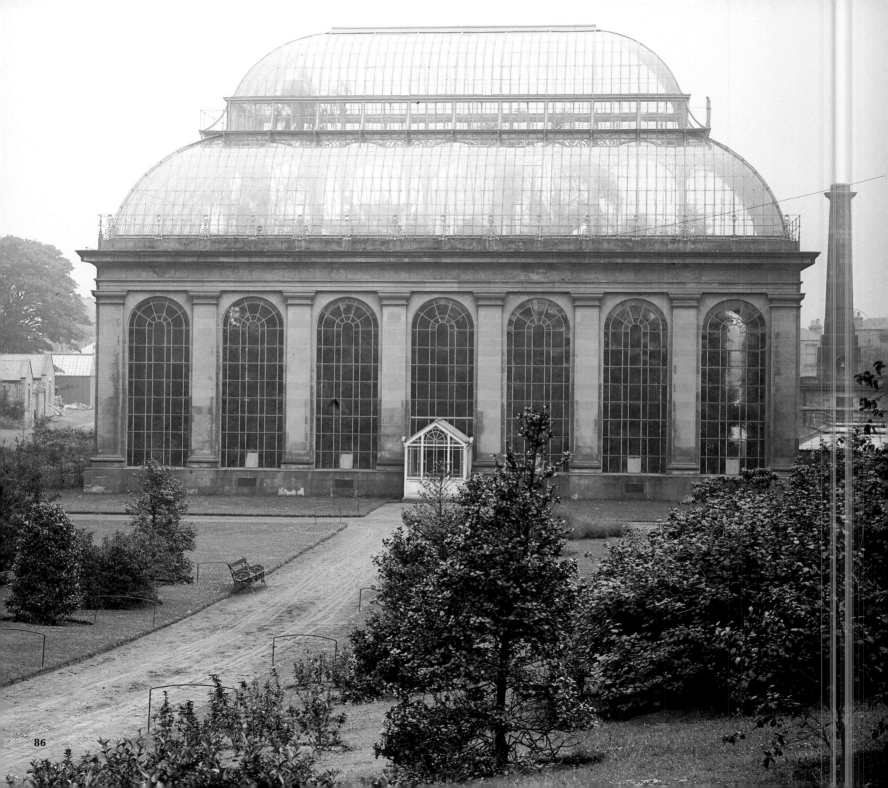

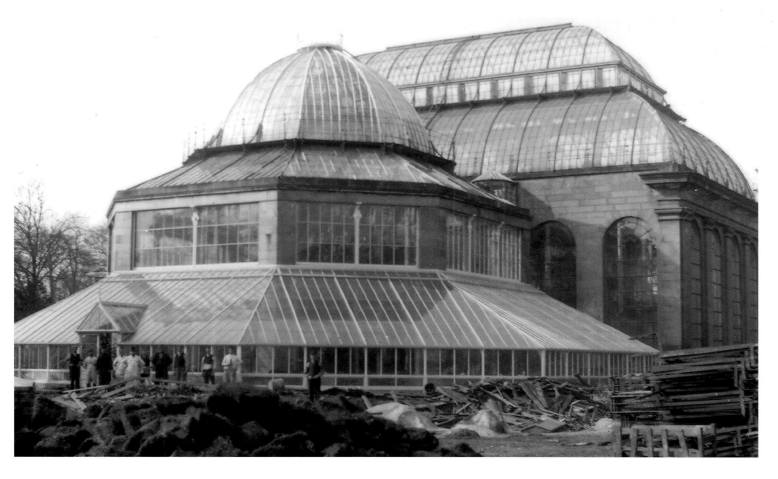

◀ A lovely shot of the Temperate Palm House, its window detail mirrored in the porch it once had, with side door to prevent drafts entering straight into the building. Despite this, the house presumably needed airflow that day as the lower pane at the centre of each window is open. To the left, we can see some of the maintenance buildings and to the right, the Boiler House that heated the glasshouses with the Garden bell on its chimney. The bell was rung to indicate the beginning and end of working periods and is currently on display in the John Hope Gateway. There is a story at RBGE that one of the work ponies knew exactly what the bell meant and would disappear off to the stables as soon as the shift ended, whether he was in the middle of a task or not! c.1905

▲ The Tropical and Temperate Palm Houses from the rear – a view the general public does not usually see. The Tropical Palm House, built in 1834, has changed much from its appearance in James Duncan's photograph on page 82 – it was given a domed roof in 1860 and 'skirts' between 1892 and 1893, possibly the occasion meriting this photograph. It may be that all the timber and turf in the foreground relate to the sinking of foundations for an Aquatic House in this area in the 1890s. The project faltered in the early stages and was never completed.

¼ DF 34, c.1890–1900, A.D. Richardson

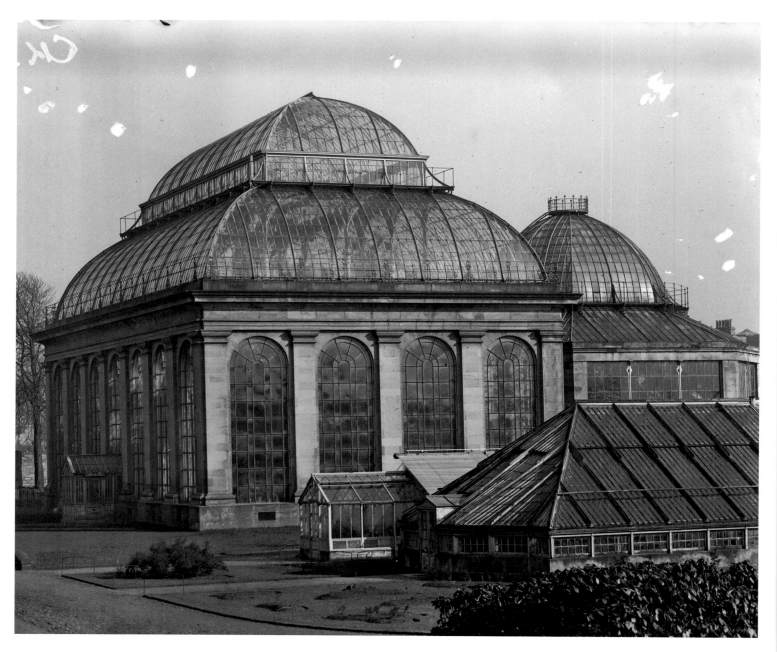

The Temperate and Tropical Palm Houses viewed from the south-west with the Fernery House in the foreground. ¼ CK 39, c.1900–1906, D.S. Fish

A desolate Laurence Baxter Stewart, then Foreman of the Glass Department, in front of the Fernery after it had been demolished by a gale in around 1906. It was reported in one of the gardening journals in May 1907 that money had been granted to RBGE by Parliament for a new Fernery, "a structure at present much required in the establishment". We can see why! The glasshouses are frequent victims of high winds.

½ CM 18, c.1906, D.S. Fish

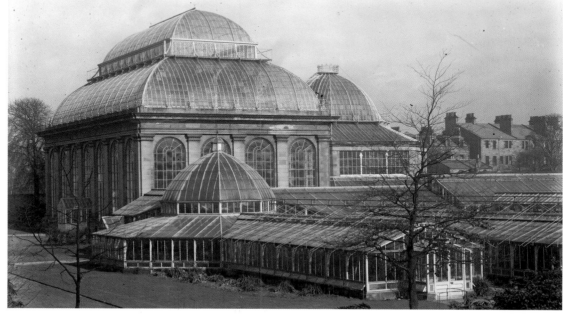

The new Fernery was constructed shortly after funding was received in 1907, and was completed in 1908 – here it is under the dome in the foreground in March 1924.

½ BJ 35, March 1924, R.M. Adam

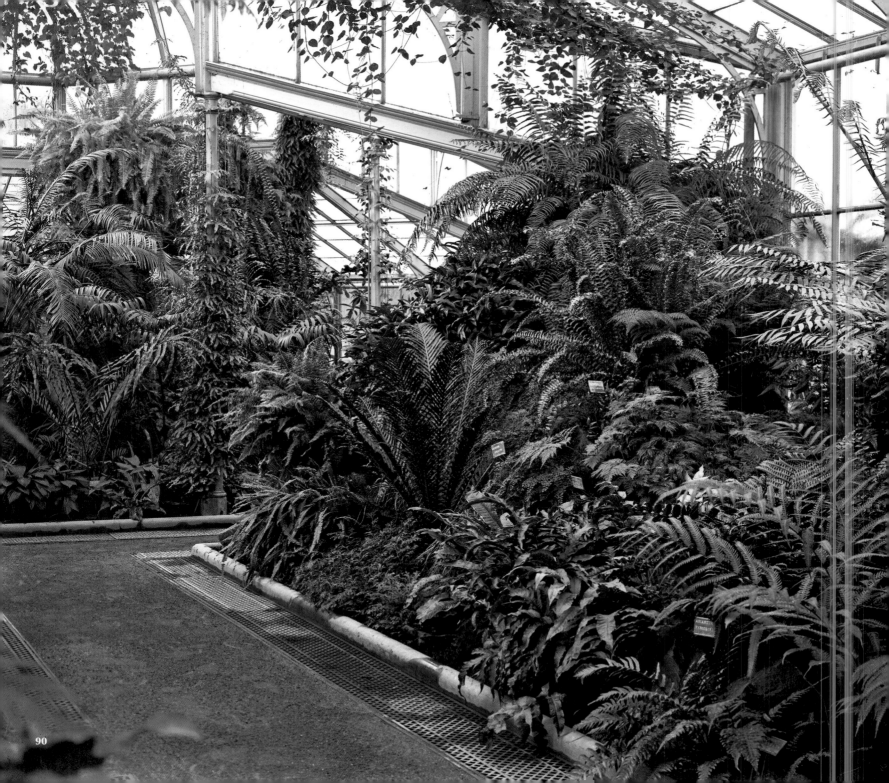

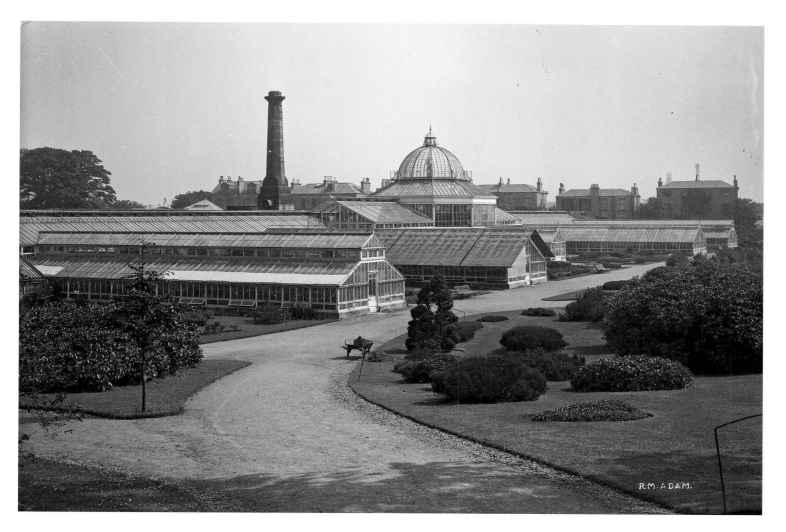

◀ View of the brand new Fernery from inside shortly after its construction in December 1908. Alongside a range of fern species such as *Adiantum*, *Blechnum* and the tree fern *Dicksonia*, other plants, such as cycads, can be seen. 1/1 Y 09, 11 December 1908, attrib. to Prof. Farmer

▲ The post of official photographer or 'Assistant in the Studio' was created for Robert Moyes Adam in 1915, but he began, like most of our early photographers, as a gardener who happened to take photos (he started at RBGE in 1903). Here is one of Adam's early photographs – a beautiful view of the Glasshouse Range in June 1905. It can be seen that the Range, which stood at RBGE from the mid-1890s to the mid-1960s, consisted of a circular domed Centre House with two corridors extending from it to the east and west, from which various plant houses, each adapted for different plants and environments, could be accessed. The Orchid House, to the centre right of the image, has been manually shaded using external teak blinds. 1/1 L47, June 1905, R.M. Adam

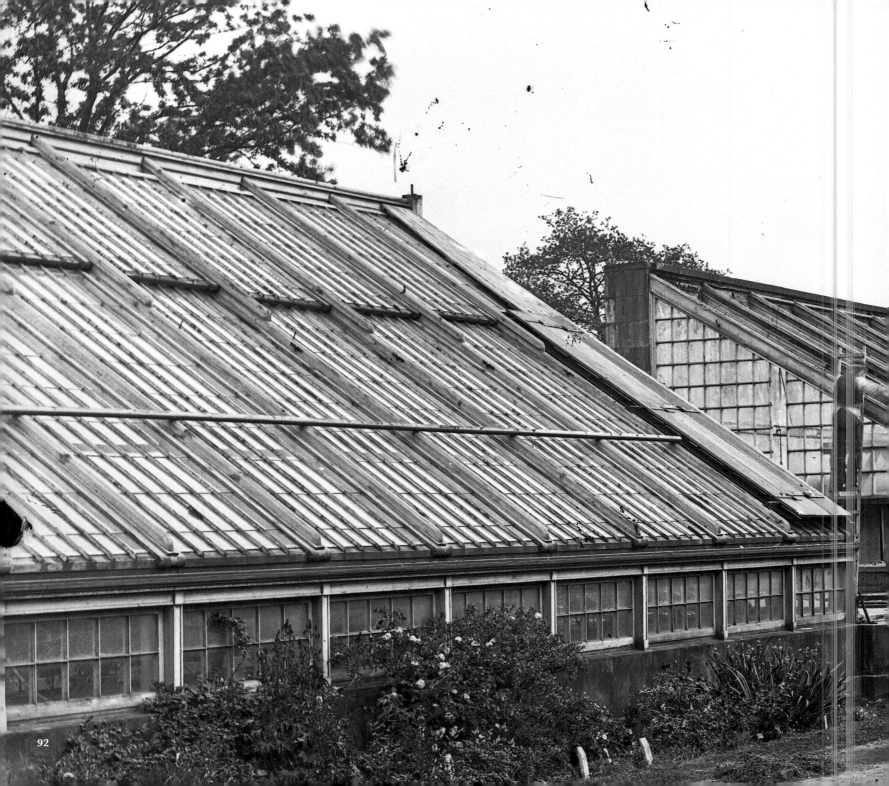

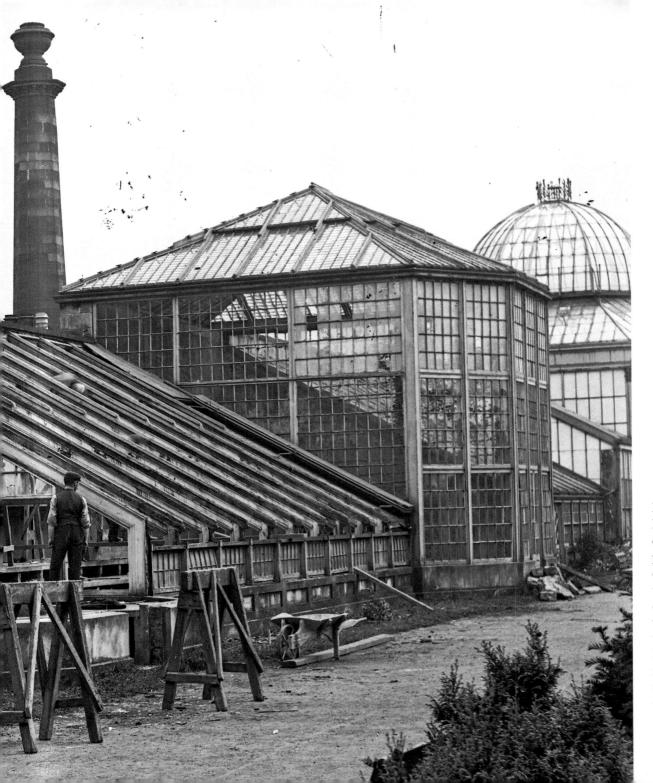

Prior to either of the Palm Houses being built, there existed the long range of plant houses to the south of them. This photograph, taken in 1894, gives an idea of what the earliest range would have looked like, with tall square houses – here, one has just been dismantled to make way for something more contemporary.

¼ DF 29, 1894, A.D. Richardson

93

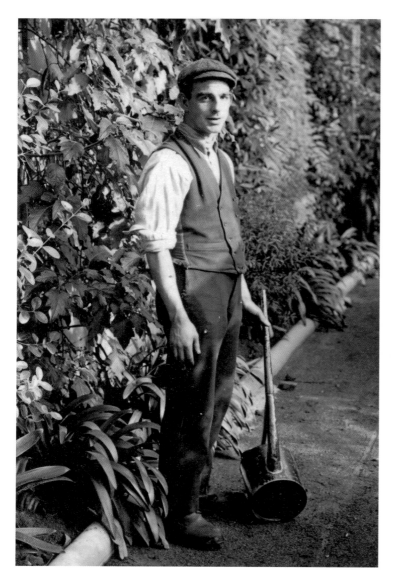

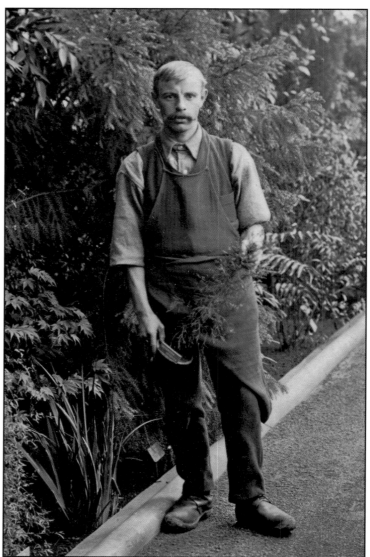

A gardener in one of the corridors which extended from the Centre House. The unusual way in which watering cans were often held in these old photographs might reflect the long camera exposure, or perhaps the way in which the cans were filled by dipping them into one of the slate water tanks located around the glasshouses.

No.949, c.1900–1906, attrib. to D.S. Fish

A gardener in one of the Plant House corridors doing what is known as 'plunging': temporarily placing potted plants into the soil to fill out displays. Because they remain in their pots the plants can be easily removed when no longer required, or when they have finished flowering.

No.971, c.1900–1906, attrib. to D.S. Fish

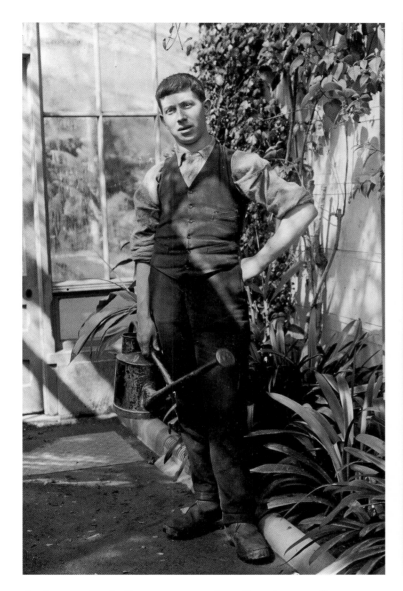

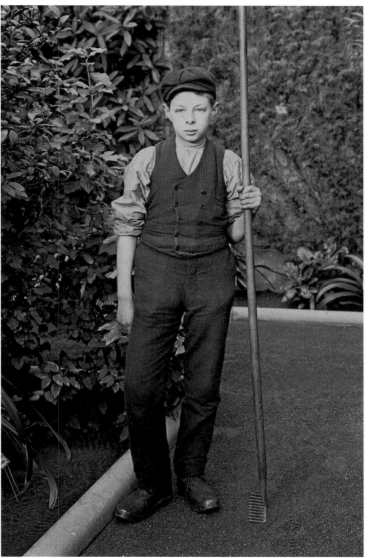

Andrew R. Cosh, "a young man of sterling character", was a probationer gardener at RBGE between 1907 and 1910. Shortly after leaving us he emigrated to America, eventually working at an estate in Hamilton, Massachusetts. No.952, 1907–1910

David Wilkie who started his career at RBGE in 1906 at the age of 14, raking the grit paths in a glasshouse corridor. From small beginnings he was promoted to 'gardener in training' in 1910, and went on to become Foreman of the Alpine Department, Assistant Curator and Senior Experimental Officer at RBGE, as well as an authority on *Gentiana*. No.938, c.1906, attrib. to D.S. Fish

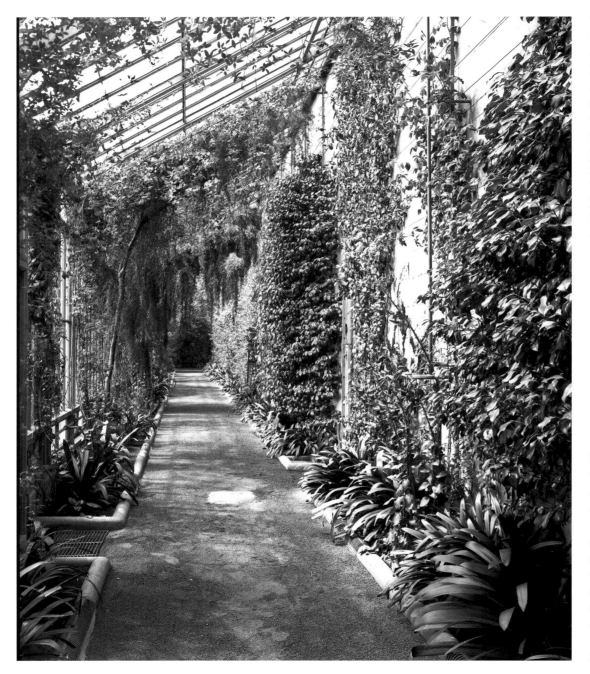

Two photographs comparing the same Glasshouse corridor to the east of the Centre House taken around 50 years apart. The plants are clearly flourishing in this environment and it is noticeable that the grit paths, that would have required frequent raking to keep them looking good, have been replaced with irregular paving slabs.

1/1 F 05, c.1900

▶ Clearly the corridor was where many species of climbing plants were trained, as well as *Begonia*, *Pelargonium*, *Viburnum* and *Datura* with their stunning large, bell-shaped flowers. The contrast between the light and shade in these old photographs provides a striking effect, but the corridor in full colour must have been incredible.

5/4 L 30, c.1950

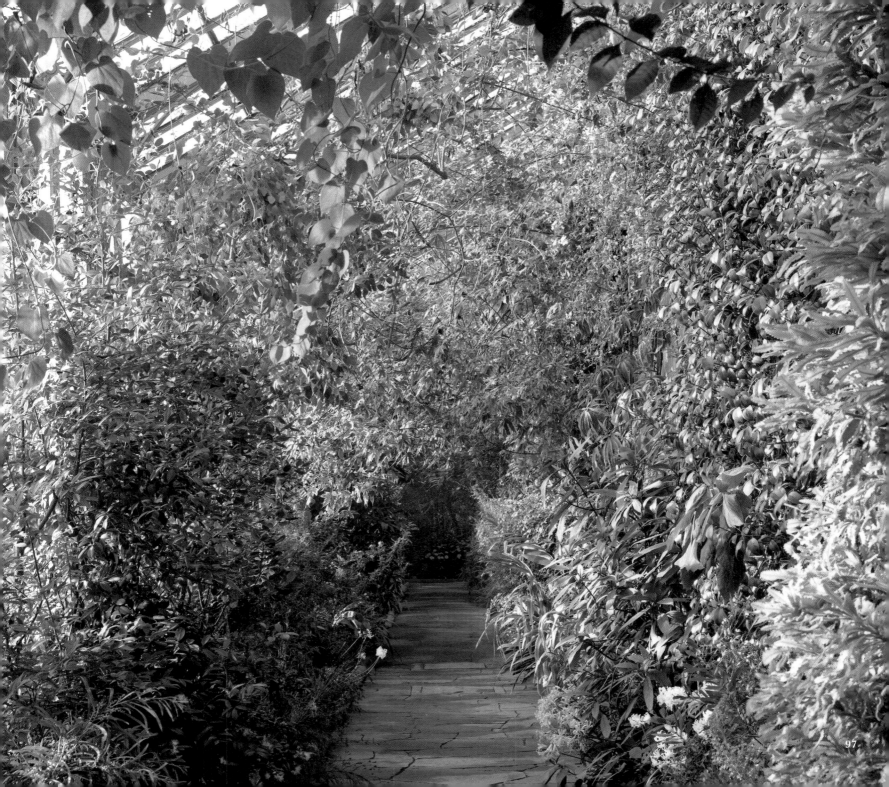

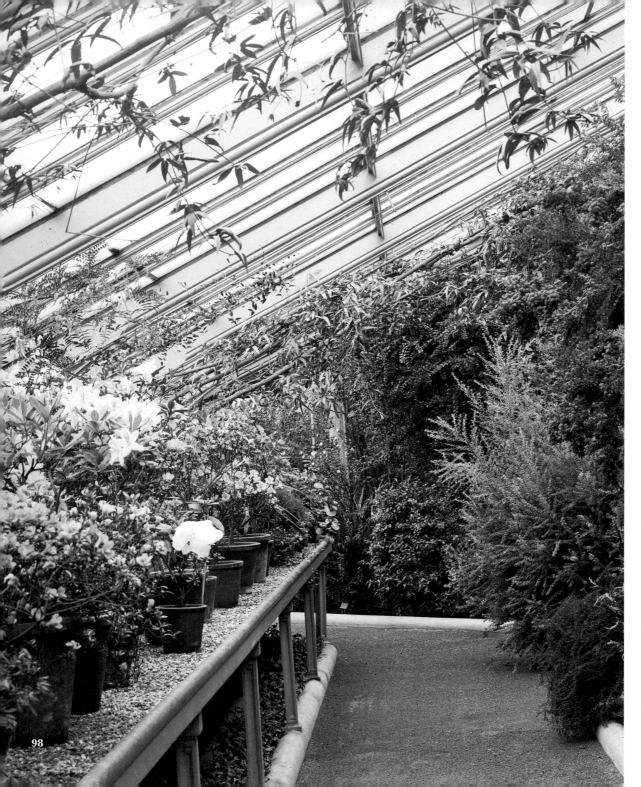

◄ The Centre House was packed full of trees and shrubs including *Camellia*, *Magnolia* and *Acacia*. *Fuchsia* and passionflowers draped from the ceiling. The stages were used to showcase new and interesting plants, florist's flowers and subtropical species.

1/1 P 15, c.1906

► One of the Stove Houses populated by the *Nepenthes* collection, a type of insectivorous pitcher plant, here suspended from the ceiling. The grill in the passageway allows for heat to rise through the floor. Stove Houses were, as the name implies, heated to a high temperature.

½ CJ 41, c.1900–1906, D.S. Fish

98

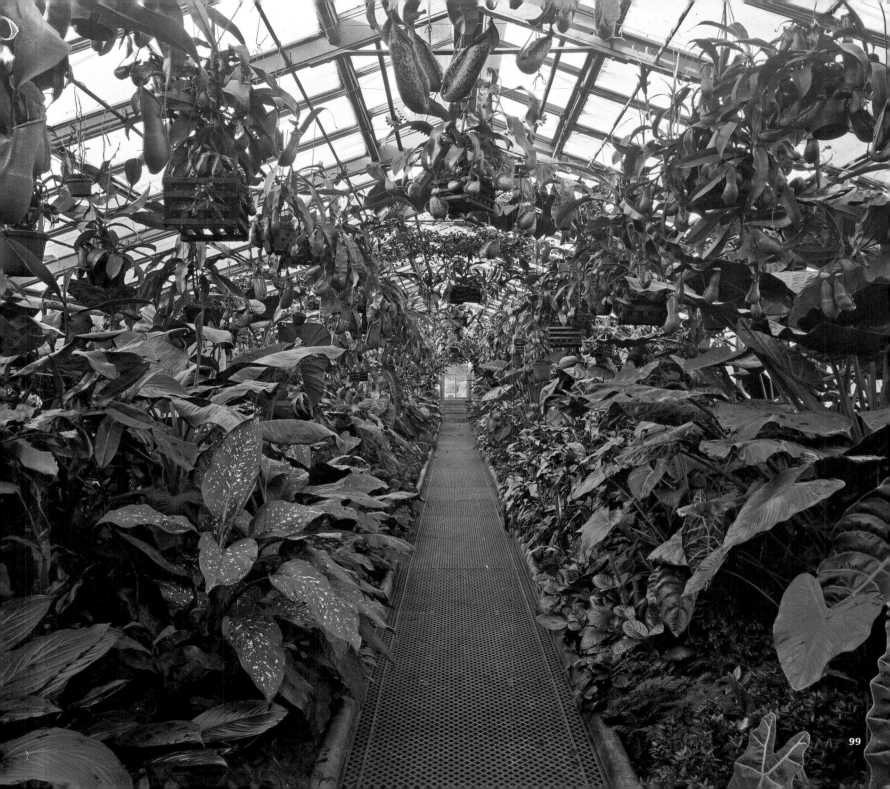

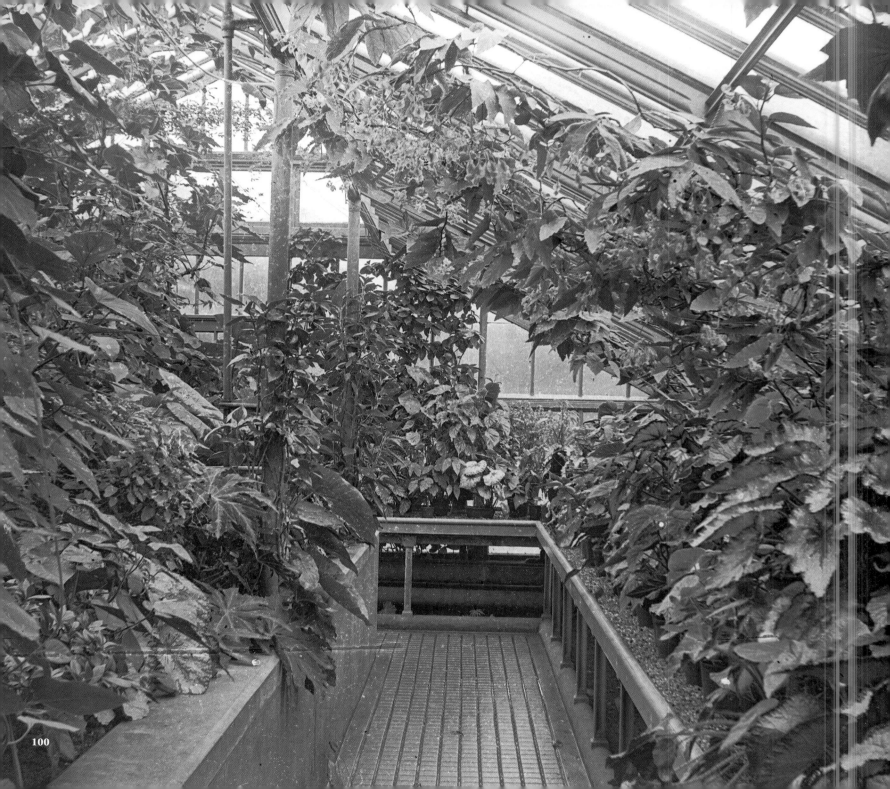

◄ The Begonia House in around 1905, likely containing species of plants collected in 1880 on the island of Soqotra by Isaac Bayley Balfour (Regius Keeper/Director of RBGE, 1888–1922), and still researched at RBGE today. *Begonia socotrana* was introduced to cultivation by Bayley Balfour, becoming a parent of many of the free-flowering *Begonia* which became very popular.

¼ CN 30, c.1905, D.S. Fish

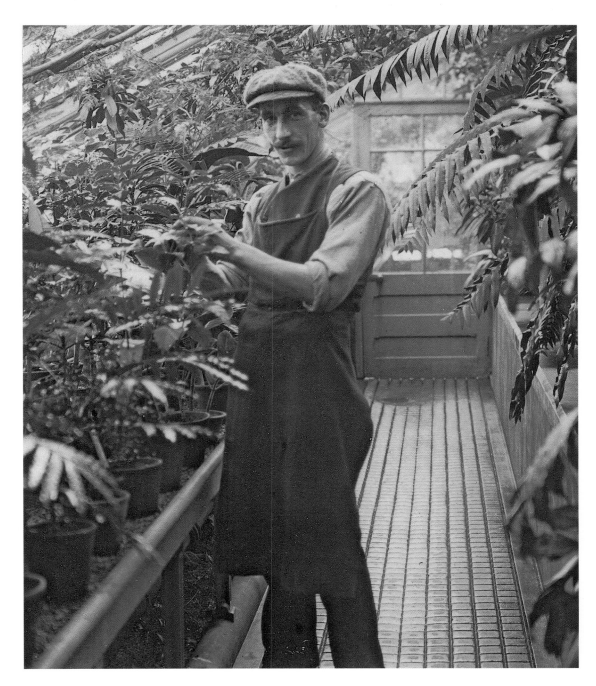

▶ A gardener tends to plants in one of the Stove Houses. The distinctive tiles on the floor help the atmosphere to stay moist – the floor is dampened and the water is held between the joins which increases humidity.

No.955, c.1900–1906, attrib. to D.S. Fish

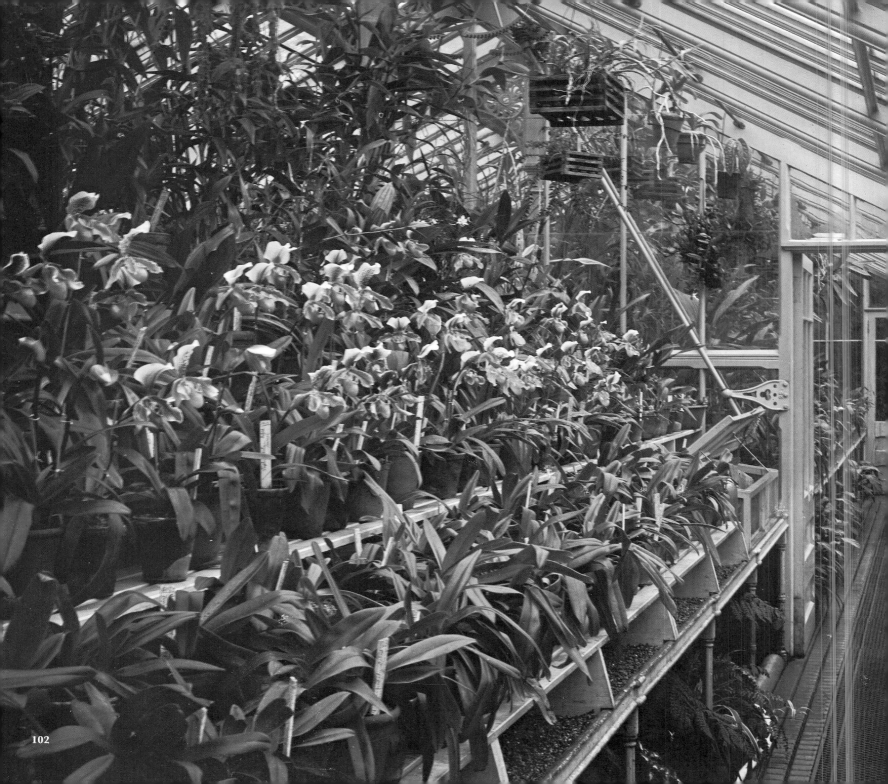

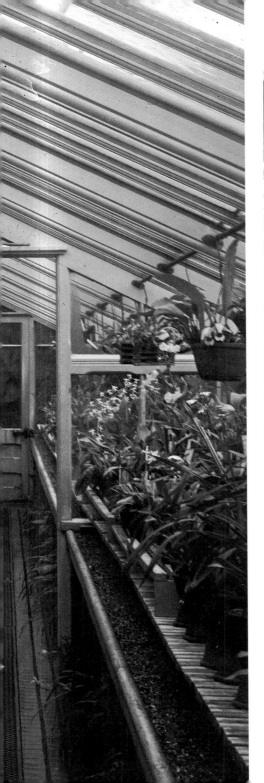

◀ The Orchid House, showing the plants displayed in clay pots to allow for better drainage, staggered on staging so that each and every one can be seen as clearly as possible. Gravel has been spread along the benches to help increase the humidity in the house. ½ BO 36, 3 Feb 1926, R.M. Adam

▲ Just to show that even in establishments with excellent reputations, such as RBGE, accidents can happen! This is the Bromeliad House after a hot water pipe burst – once the heating has been lost, plants can quickly die, but in this case it looks like there has been damage from the escaped steam as well. 1/1 AA 48, 30 August 1909

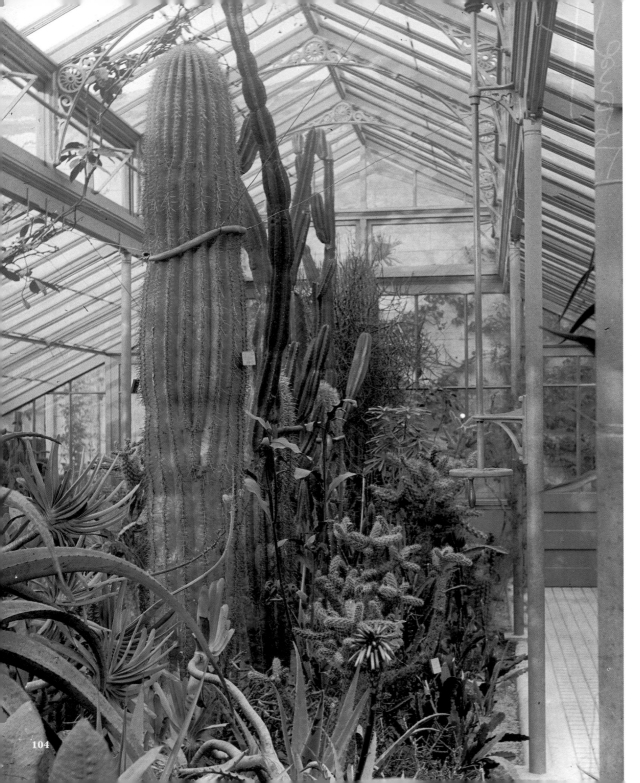

One of the taller houses
(for obvious reasons) at the
eastern end of the Glasshouse
Range is the Succulent House
with its collection of aloes and
cacti – a popular house for
"the lover of the grotesque"
according to our 1933 Guide
Book. The manual ratchet for
opening windows to ventilate
the house can be clearly seen.

¼ AE 06, c.1910–1914

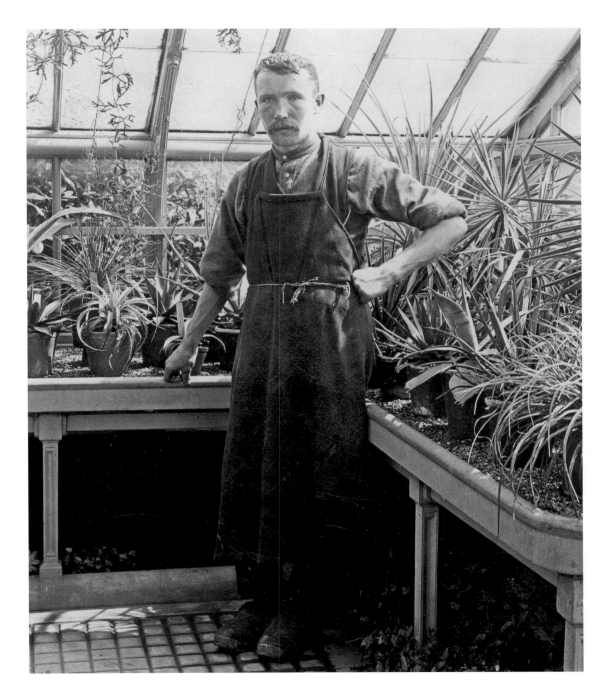

Thomas Sherlock amongst the *Agave*, *Puya* and *Dracaena* in the Succulent House. Keen to learn and improve himself, Sherlock was attending night classes in Edinburgh before he started as a probationer gardener in 1907. He returned to his home county of Sligo in Ireland three years later.

No.960, 1907–1910

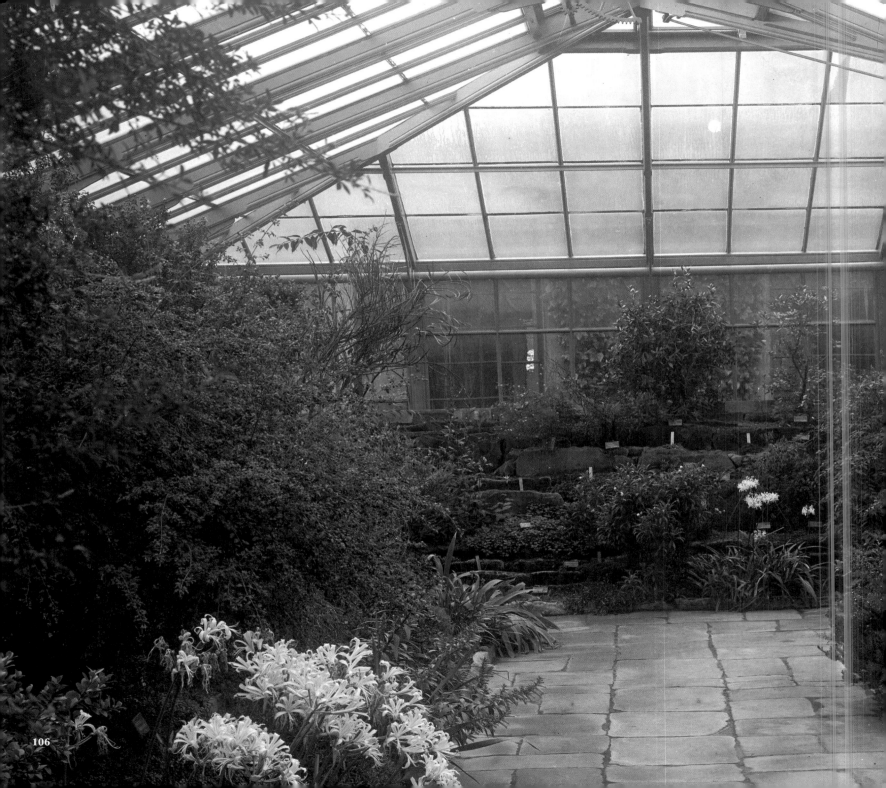

The Alpine or Rock House which stood at the far east of the Glasshouse Range was very different in appearance from the other houses in that it was set out as an indoor rock garden, originally with small red sandstone terraces, to display alpine plants more appropriately than what was at the time "the usual rows of pots" on staging. Although alpines are considered tough plants, many despise the dampness of the typical British winter. Here they could be protected from that, and the house only required heating during exceptionally cold weather. Indeed, the conditions in this house were such that our contemporary RBGE Guide Books were proud to boast that alpine species from South Africa, Australasia, the Mediterranean and the Himalayas lived happily side by side here.

1/1 EL 46, late 1930s

107

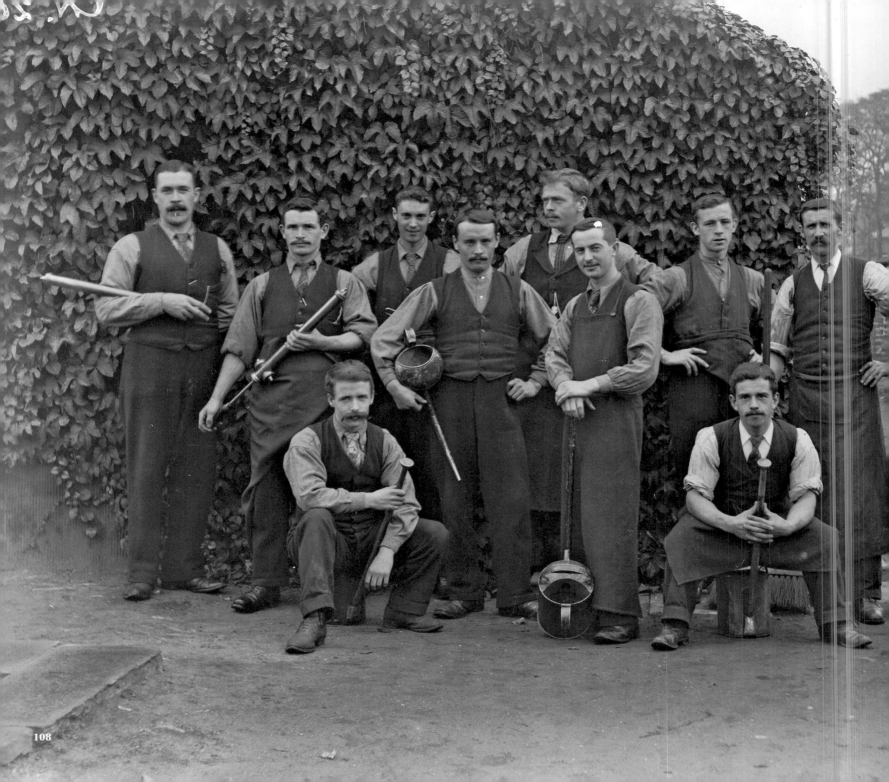

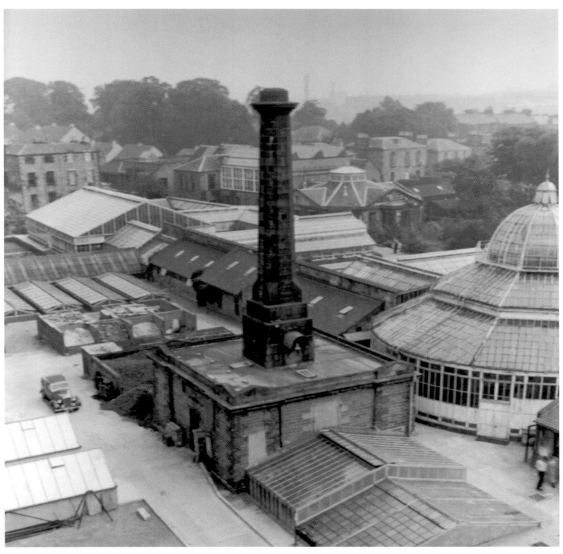

◄ A group of gardeners posing by the old Glass Department holding instruments for syringing, pest control and damping down. ½ CN 20, c.1904–1906, D.S. Fish

▲ View behind the Glasshouse Range from the roof of the Tropical Palm House looking towards the Boiler House with its chimney and bell, and the coal heap used to feed the boilers. Boiler stoking would have been a fairly constant job, including night shifts. c.1930?

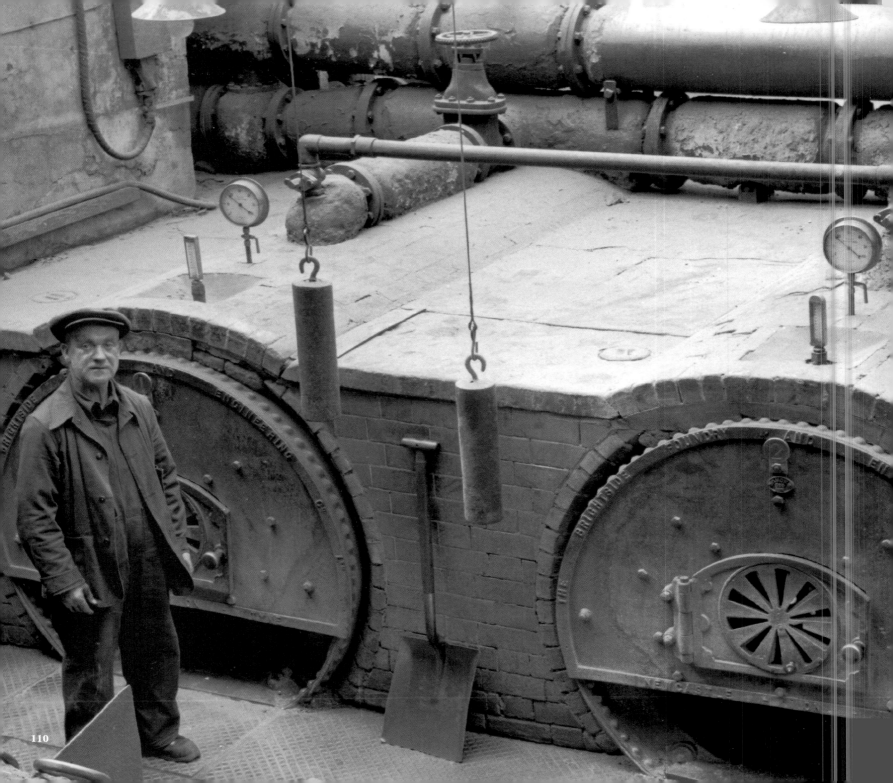

◀ Just before the new research and propagation glasshouses were built in the north-east corner of the Garden in 1955 the way in which the houses were heated was completely modernised. The old hot water boilers, which needed constant refuelling by coal stokers, …

7 January 1955

▶ … were replaced by more efficient and flexible oil-fired high-pressure steam boilers with thermostatic controls like this one. Now the entire Glasshouse Range could be heated by one boiler house rather than three, leaving room for more glasshouses.

7 January 1955

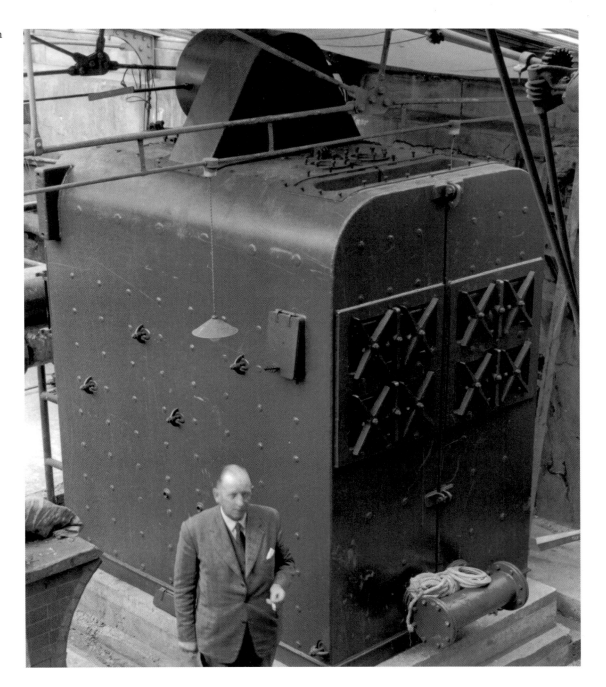

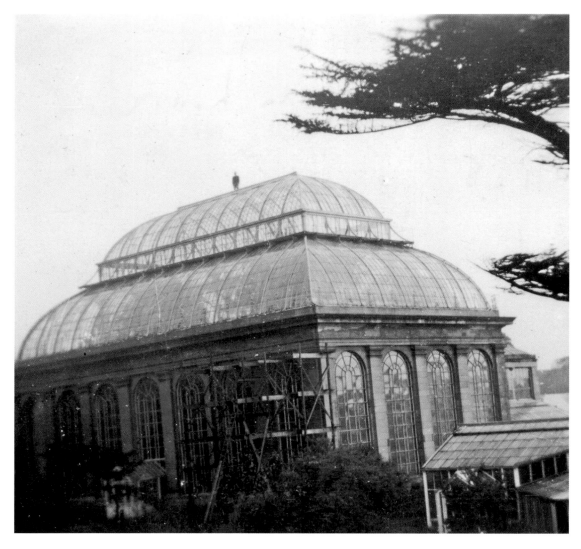

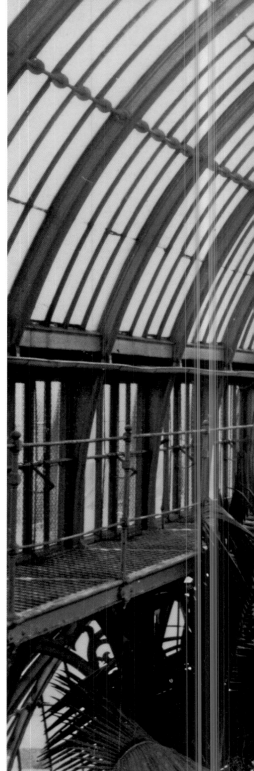

▲ Gardener Stuart F. Hayes showing he had a head for heights on the roof of the Temperate Palm House in 1938. The scaffolding on the outside of the Palm House may have been to enable gutter repairs.

1938, S.F. Hayes collection

▶ Photograph taken by Stuart F. Hayes from the top gallery of the Temperate Palm House in January 1937 showing the striking geometry of the roof structure. Some of the palms were removed 50 years later in the 1980s as they had reached the roof by then.

January 1937, S.F. Hayes collection

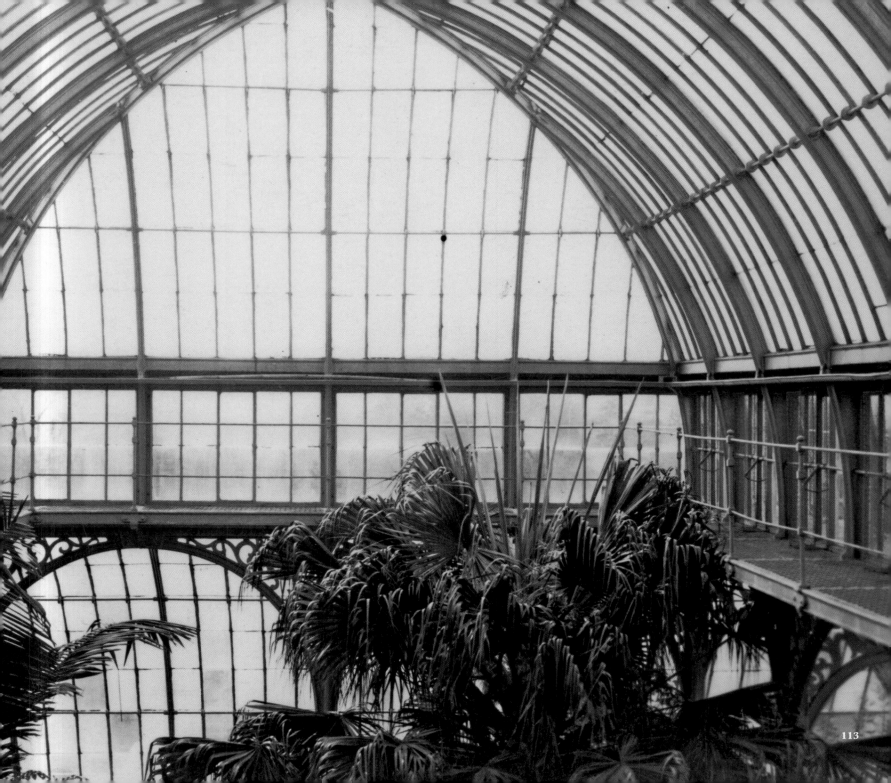

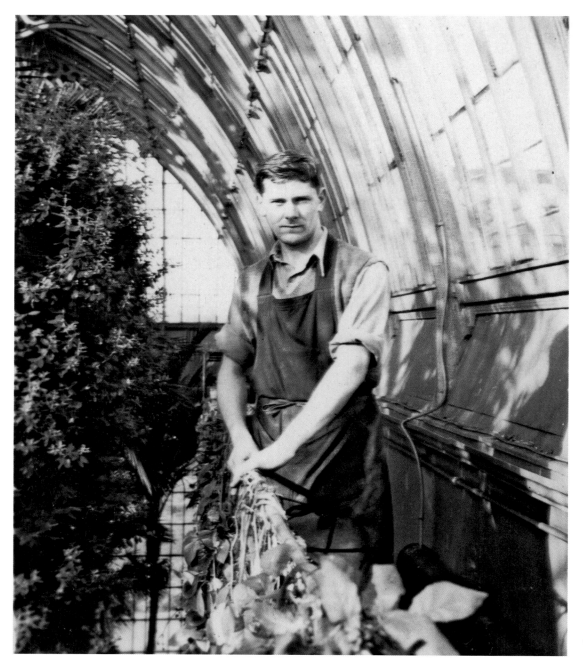

◀ Henry (Harry) Moseley in the lower gallery of the Temperate Palm House c.1937–1938, photographed by his friend Stuart Hayes. Harry enlisted during World War Two, becoming a Royal Scots Guard. Stationed at a mansion in Italy, he enjoyed spending his spare time tending the garden, where tragically he was spotted and killed by a sniper in October 1944.

c.1937–1938, S.F. Hayes collection

▶ Lawrie Buchan, on the left, who was Assistant Curator of the Glass Department, scaling the Tropical Palm House with colleague John Bryan in the 1950s.

c.1951–1960

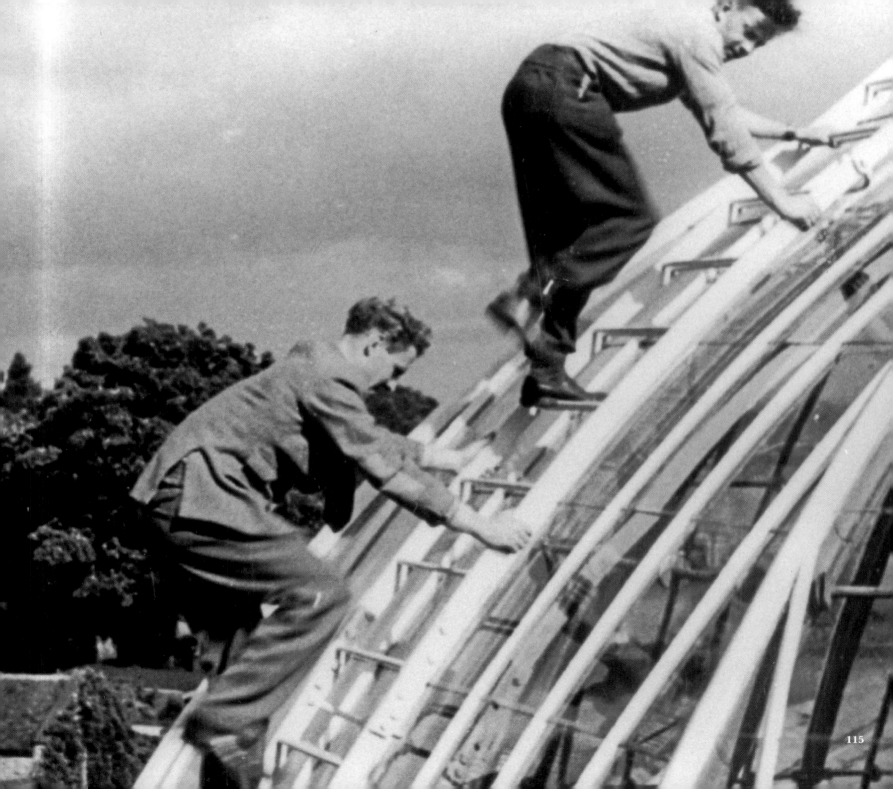

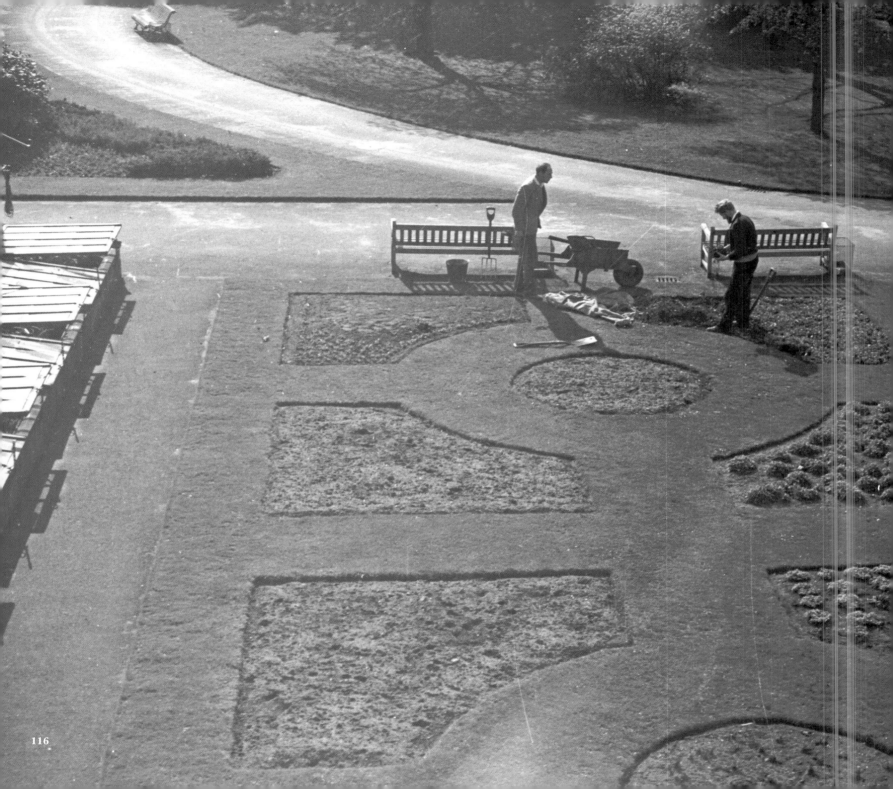

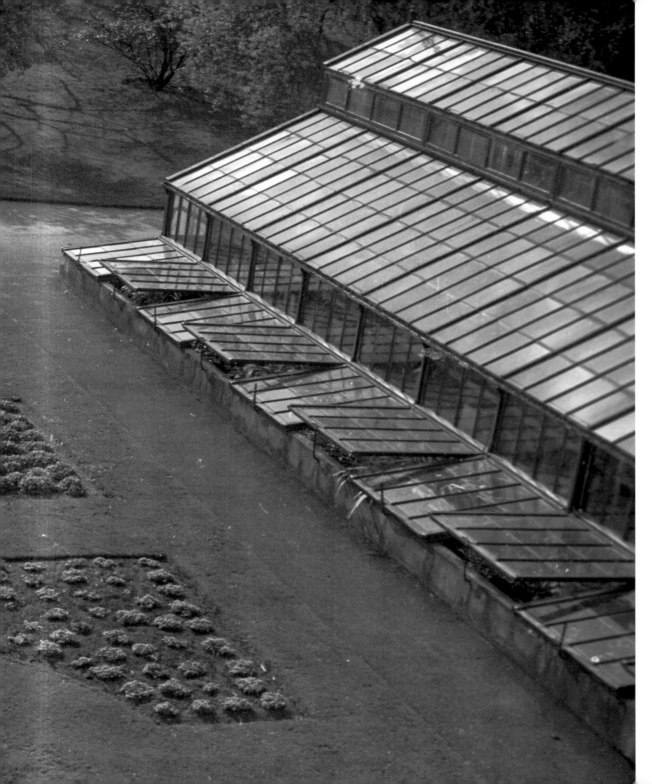

The spaces between the glasshouses were filled with formal bedding. Here two gardeners are planting up the beds to maintain seasonal interest beside the old Begonia House.

C.1950 – 1964

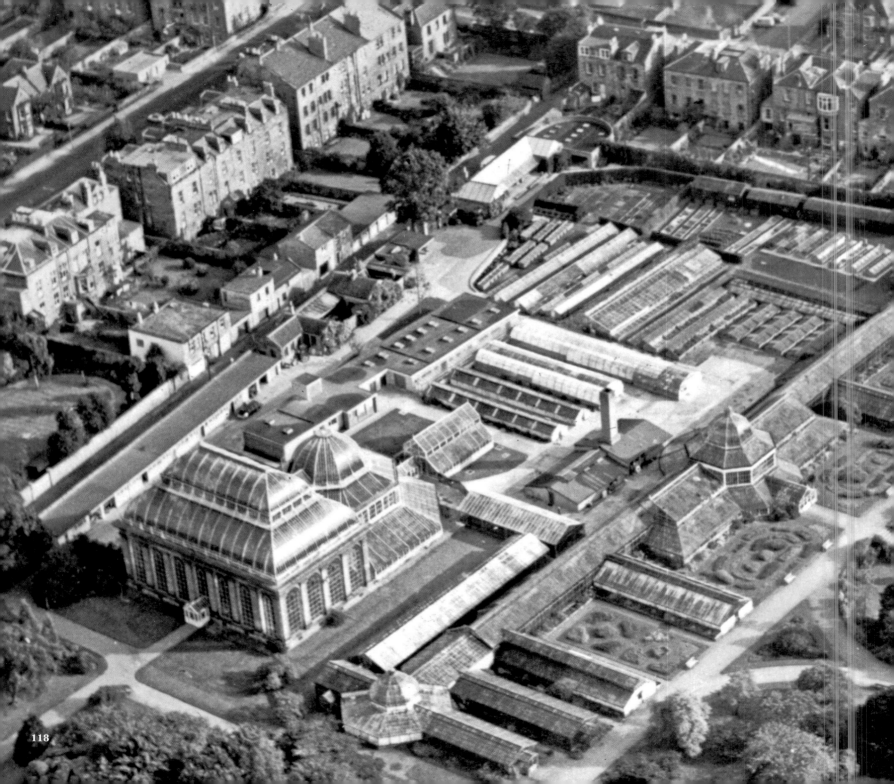

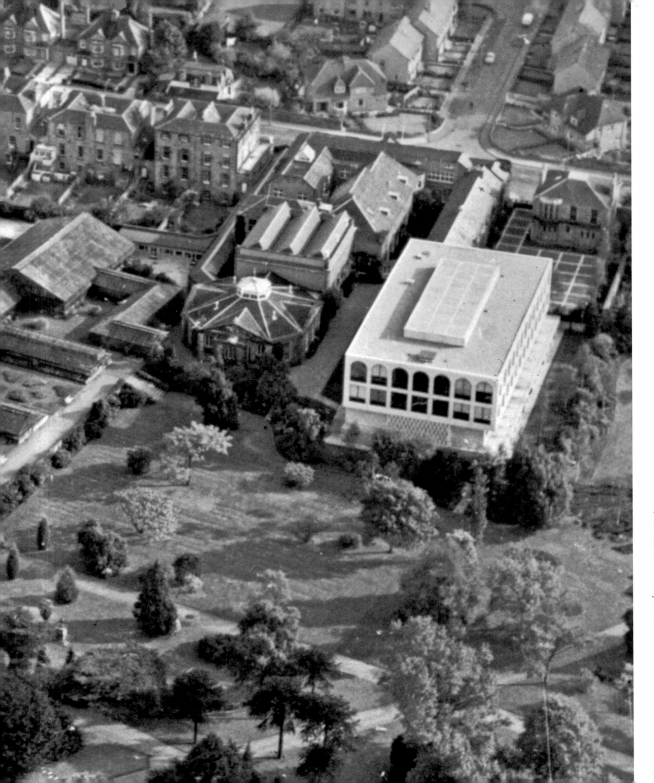

An aerial view of the Glasshouse complex taken in 1964. To the right, the white Library and Herbarium building has just been completed and to the left, behind the soon-to-be demolished Glasshouse Range, lie many buildings still in use today, such as changing rooms for the Horticulture staff.

1964

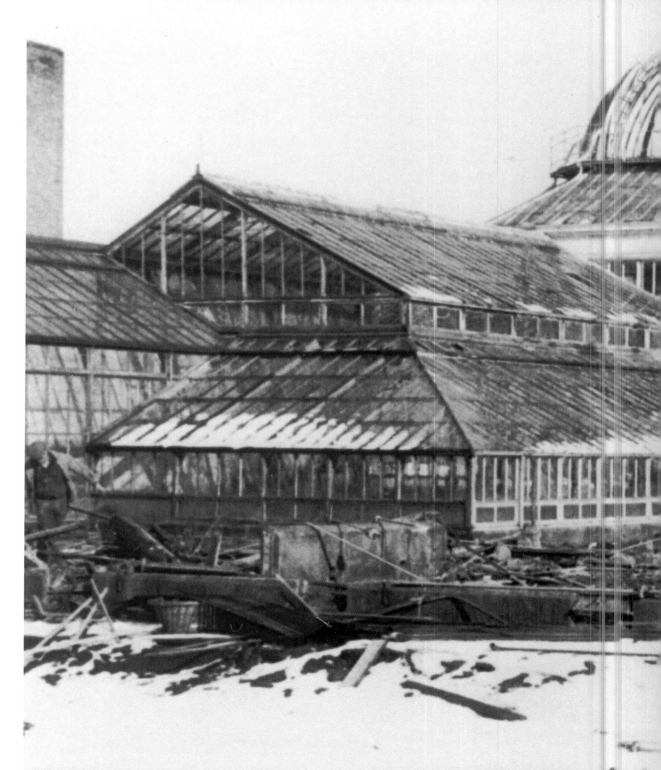

The dismantling of the Glasshouse Range, which began late in 1964. Sad as it is to see Victorian buildings disappearing, it was thought that some of the houses had become dilapidated to the extent that they could no longer be used safely, and the 1960s were a time of looking forward to the future.

Late 1964

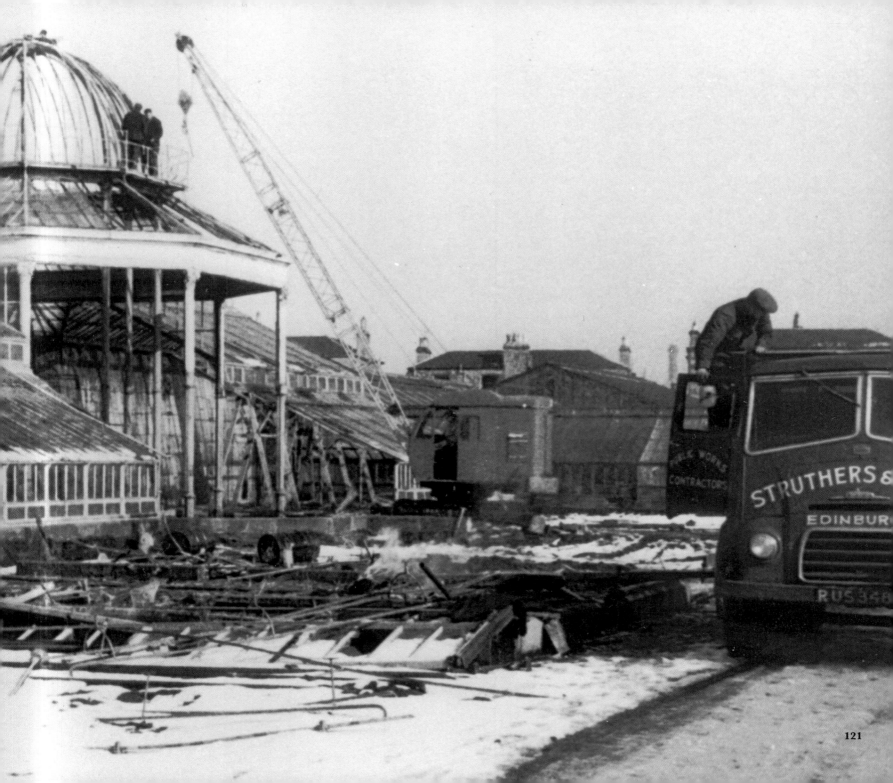

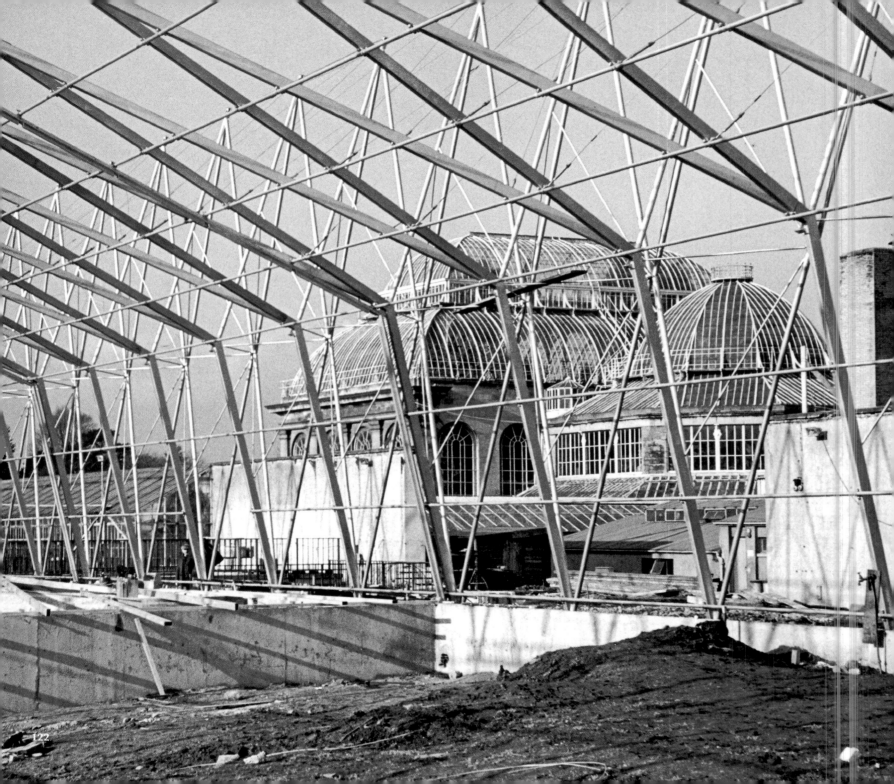

◄ View from inside what is now the 'Rainforest Riches' house inside the new 'Exhibition Planthouses' during its construction, looking towards the Palm House complex.

1965–1967

► A group of gardeners 'planting up' inside the new Arid House before the glazing has been finished, judging by the man climbing the walls.

IMG-068, 1967–1968

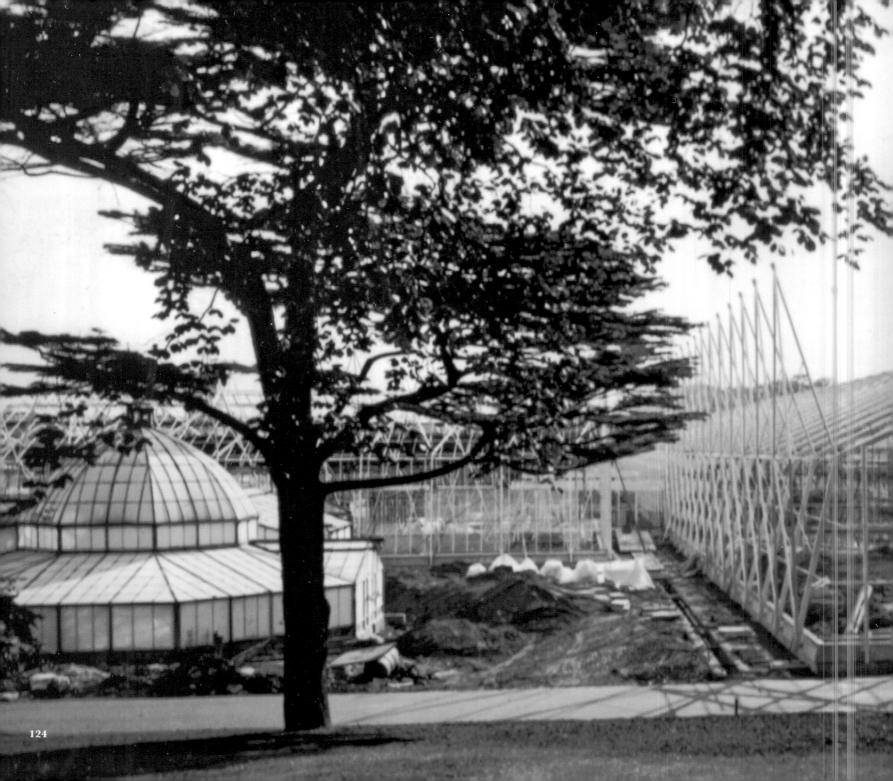

◀ View looking towards the west end of the new 'Exhibition Planthouses', opened on 25 October 1967, and the Temperate Palm House. Between them the old Fernery still stands where the Fossil Lawn is today.

c.1968

▲ And finally, we close this selection of images from the RBGE Archives with a photograph contrasting the old with the very new. Whereas the glass structure of the old houses was supported by internal columns, the new 'Exhibition Planthouses' have all their support pulling them up from the outside, leaving more space and flexibility for the planting inside. The old system of roller blinds to provide essential shade for the new plantings has been replaced too, by whitewashed glass. Perhaps a 'low-tech' option in this up-to-the-minute house, but one still used today.

Late 1960s

Acknowledgements

Written and compiled by Leonie Paterson
Production, editorial and project management by Alice Young
Design by Caroline Muir

With special thanks to:

Hamish Adamson	Simon Crutchley	Michael S. Hayes	Jimmy Ratter
Scott Ainslie	Martyn Dickson	Ian Hedge	Roddy Simpson
Pete Brownless	Edna Fedonczuk	Fiona Inches	Geoff Turner
Rosemary Carthy	Amy Fokinther	David Knott	
Anne Cormie	Tony Garn	Phil Lusby	Robert Unwin
Jane Corrie	Graham Hardy	Lorna Mitchell	Lynsey Wilson

The Friends of RBGE Small Project Fund
All anonymous photograph donors
And to all the staff, students and volunteers who have worked in our beautiful Garden from its beginnings in 1670

References:

(p. 12) Farrer, R. *My Rock-garden*. London: Edward Arnold (1907), pp. 7–8.

(p. 34) R.E. Cooper *The Journal of the Scottish Rock Garden Club*, v13 (September 1953), pp. 222–224.

(pp. 48–49) Cant, M. *Edinburgh and the Forth: Through the Lens of a Morningside Photographer*. Catrine: Stenlake Publishing Ltd (2010).

(p. 65) *The Garden*, August 1924, p. 535 and Journal of the RBGE Guild, vIII, p36.

(p. 85) *Transactions of the Edinburgh Field Naturalists and Microscopy Society*, 1912–13, pp. 48–49.

(p. 89) The Garden, May 1907, p. 210.

Other information obtained from:

Fletcher, H.R. and Brown, W.H. *The Royal Botanic Garden Edinburgh 1670–1970*. Edinburgh: HMSO (1970).

Journals of the Royal Botanic Garden Edinburgh Guild.

Rae, D. *The Living Collection*. Edinburgh: RBGE (2011).

Various Guide Books to the Royal Botanic Garden Edinburgh

We are delighted to receive any information relating to our Archive and people who have worked at RBGE.

Please contact archives@rbge.org.uk or Archivist, The Royal Botanic Garden Edinburgh, 20A Inverleith Row, Edinburgh, EH3 5LR if you have any information.